Rug Art - Rescued From Oblivion

A Hooked Rug Museum of
North America Research project

by Suzanne and Hugh Conrod

authorHOUSE®

AuthorHouse™
1663 Liberty Drive
Bloomington, IN 47403
www.authorhouse.com
Phone: 1-800-839-8640

First published by AuthorHouse 6/11/2010

ISBN: 978-1-4520-0239-2 (e)
ISBN: 978-1-4520-0237-8 (sc)
ISBN: 978-1-4520-0238-5 (hc)

Library of Congress Control Number: 2010903960

Printed in the United States of America
Bloomington, Indiana

This book is printed on acid-free paper.

Dedication

This book's title has an inescapable double meaning. It is dedicated to all those gentlefolk who have joined in this unique **"Hands Across the Border"** mission of saving a continent's rug hooking heritage from oblivion.

There are too many supporters to name individually but they range from a faithful International Board of Directors to many fine rural folk who jointly have shared their personal collections and knowledge of their ancestor's rug hooking heritage. They dramatically demonstrate that the true heart of this great art form knows no political boundaries.

Table of Contents

Rug Art
RESCUED FROM OBLIVION

Foreword

This journey in search of rug hooking history has unearthed a forgotten chapter in that heritage. In the process it has emphasized the serious void in preserving North America's oldest art form introduced to this continent by European settlement.

Preserving the memory and historic evolvement of an endangered art form is undeniably important but society's neglect of a key pioneer contribution to its own origins is a tragic void that demands action before loss occurs..

Ignoring the heritage of a utilitarian craft which has in-corporated the embodiment of a continent's struggles for survival and cultural expression is unacceptable-but denying recognition to those who created our early art with the point of a charred stick on a recycled burlap feed bag is akin to destroying the cave drawings of our native people.

It is to the undying credit of those modern day rug hook-ers who have rallied around efforts of a small group of Nova Scotia rug hookers and researchers that a continent wide fire has been ignited – a joining of hands between the women

of two great nations to save what heritage is possible and to build an archives for future generations to appreciate.

Elderly, mostly widowed, many of these rug crafters of yesteryear still live in backwoods villages and seaside hamlets. They are jewels of the earth. Their naive skills are untarnished by modern teaching, many hook alone in small homes still heated by wood stoves and their hooking remains utilitarian, designed to warm drafty floors. They provide a virtual flashback to another era.

Bypassed by modern highway systems, reluctant to display their RUGS FOR SALE signs for fear of being targeted for personal attack, these senior aged women had virtually abandoned the only creative work they ever knew. Despite it all author Suzanne Conrod not only discovered the key to significant rug hooking history, but has led a major effort to replicate the past, honor its pioneer founders and lay the groundwork for its evolution as a fine art.

To Warm the Drafty Floors of Pioneer Homes

Early settlers arrived in old Acadia with little more than the clothes on their backs. Pioneer log cabins and wooden floors were drafty and cold in winter. Hooked mats were a welcome amenity to warm the floors and in some cases used as bed coverings. (Scene at King's Landing. New Brunswick)

PROLOGUE

Can We Count You In?

As a sequel to her purchase of the relics remaining in the old Garrett factory Suzanne Conrod opened a hooked rug marketing outlet at a point in life well beyond retirement age. Her objective in doing so was to assist her rural based rug hooking friends, mostly widows, to augment their small pensions. In the process she continued acquiring and preserving important vestiges of early rug hooking history.

She shared her concept of a future Museum with rug hooking colleagues during a winter holiday in Florida and the "dream" grew. At the insistence of her former teacher Sarah Paddock and rug hooking friend Mamie Adair, her original concept of a small Nova Scotia rug museum has evolved to become an international challenge. Saving rug hooking heritage has led to the creation of a Hooked Rug Museum of North America Society in Canada and a Hands Across the Border movement in the United States reuniting the heritage of the pioneer art of two great nations.

The Original Rug Lady Circa 1892
The John E. Garrett Rug Factory
New Glasgow, Nova Scotia

Rescued from Oblivion

Chapter 1

"In those days our great-grandmothers were greatly handicapped by lack of proper materials. Her first move was to get an oat bag or potato sack, cut it open and sew it on a frame. Then came the design. If she wanted a strictly geometrical pattern, she often used small plates and butter chips and even bricks by laying them on the burlap and tracing around them"(The New Glasgow Evening News 1934)

The Drama of Discovery

A "'bit of antiquing" unexpectedly evolved into an exciting and hazardous adventure that crisp 2004 Fall day in New Glasgow, Nova Scotia.

It all transpired in a century old basement infused with the grime, dust, cobwebs and mould accumulated from a long forgotten past. Unknown to us two retirees starting out on a romantic wedding anniversary trip it would be the curtain raiser to a project that would consume the rest of our lives.

1

Garrett's By-the-Bridge Antiques is a rambling frame structure- a combination of two 19th century buildings which were later joined in the middle for expansion of a once booming international rug pattern factory. Its location was near the centre of a historic industrial area with strong Scottish overtones.

The shop's current owner-manager Edward "Eddy" MacArthur purchased the property and remnants of stock and equipment left in the former John E. Garrett (1892) Rug Pattern Factory during the mid 1970's when Cameron Garrett (the last of the Garrett dynasty of rug pattern manufacturers) decided to wind down the business. Eddy also happened to be the last working manager of that old factory.

We found the antique emporium's stock that day to be a mixture of new and old. A few faded old hooked rugs were displayed on the floor but it was a unique cylinder type of rug hooking device nestled in a showcase that caught our eye upon entry. Overall the scene was a conglomeration of old pictures, books, antique furniture and stacks of early phono-graph records-seemingly out of place amongst the gleaming Paderno stainless steel cookware, utensils and sparking new guitars with which they shared shelf space.

The genial owner was on his way to make his bank de-posit but paused to greet us and enquire about our wants. Having researched the early beginnings of this antique em-porium before starting our holiday excursion we had know-ingly targeted this particular shop in our challenging search for more artifacts and archival materials to add to a growing personal collection of heritage rug hooking items being as-sembled by Suzanne.

When Eddy stepped forward to offer aid, our first question was whether any vestiges of the old Garrett factory still remained after the closure of the plant some 30 years earlier. He pointed to the rugs we had spotted earlier and noted that one was an image of the last pattern ever designed and manufactured in the old factory. He explained that the cylindrical device in the showcase was an experimental rug hook designed in the early 1920's at another old New Glasgow firm of Steeves and Sutherland. It took little consideration for us to quickly add these two rare items to our artifact collection.

Our still unanswered enquiry begged a more complete answer. "Is there anything left of the old factory?" we asked.

Eddy's reply–"I haven't been down in the basement in the last five years, but there's still some equipment and odds and ends there!"

This unexpected response, coming after the factory's closure more than a quarter century ago gave us a shiver of anticipation.

A disappointing minute followed when we asked if we could visit the basement and its owner explained that it was a damp and hazardous area with minimal lighting and treacherous access stairs. Crippled himself by an earlier illness that limited use of one of his legs, it was obvious and understandable why Eddy was reluctant to venture into such conditions.

Sensing our disappointment and contemplating our offer to acquire a flashlight to augment the search, Mr. Mac

Arthur agreed that if we returned later in the morning he would try to take us into the basement.

It turned out to be a difficult climb for both us seniors and the owner as we cautiously ventured down a narrow and near vertical stairway which opened into a seemingly endless maze of beams, nooks and crannies, with its darkened twists and turns. The cavernous basement was liberally decorated with cobwebs. The blackened walls wore a cloak of grime and probably splattered printer's ink.

Dripping water pipes, pools of leaking water and rotting cardboard cartons flirted with each other amidst the musty smells and creeping mould prevalent in damp areas. Piles of burlap once the key for rug pattern making lay crumpled near a home made metal trough, at one time a system for washing surplus ink from paper stencils utilized to reproduce Garrett rug designs.

No Hollywood horror movie could have more dramatically replicated this inhibiting scene. It was a panorama of which nightmares are made. Flashes of dusty old equipment, a stack of water-soaked stencils, abandoned tools and a tray of varnished rug hook handles gleamed between a veil of cobwebs, all appearing in flickering glimpses under the prying beam of our new flashlight.

There was only minimal electric power supply to the basement, some not functioning. Awareness that electricity and water do not make comfortable partners did little to calm our nerves. A bare overhead bulb provided light for the stairwell but most others had long since expired. One of them did cast a pale aura on a distant corner.

Eddy indicated an old table lamp nearby and with his help

Suzanne connected it to a seemingly endless stretch of aged extension cords to provide a fraction more illumination. It was a single-file parade led by Eddy, followed by Suzanne "the lady of the lamp" and tailed by myself (Hugh) with my flashlight and a digital camera, itching for action. Each of us constantly brushing aside the cobwebs, pondering the dubious friendliness of the creepy crawlies that created them, and all the while peering excitedly into each box and container we passed. We intently scanned each blackened corner for rug hooking history as we carefully edged forward on the broken concrete that still clung to survival on an uneven floor.

From time to time Eddy would point out an item of abandoned old factory equipment, -there, he explained, was the tumbler once used to polish the metal components of rug hooks, nearby, the unusual upright lathe used to fashion them, over here a tool rack with implements still projecting from their appointed slots despite rust and an inch of accumulated grime. Even the old pattern table remained intact a crude but effective platform of ink-blackened two by fours covered with planks and topped with a smooth 8x10 sheet of some early form of plaster board. Rusted cans with peeling labels still sheltered remnants of abandoned printers ink.

Despite the seeming threats to personal safety it was for us a heart pounding introduction to early rug hooking history and a lost heritage which at the outset we had not contemplated finding and even then had difficulty comprehending. It was truly a trip back a century, a veritable time capsule of hooked rug heritage.

Overcome by the enormity of what was unfolding before

our eyes we collected what small treasures and samples we could easily transport to the upper levels where they could be assessed and hopefully acquired. Green garbage bags were stuffed with what was immediately at hand, samples from this carton and that, bits of old mechanical rug hooks, a few copies from an abandoned and water damaged stack of brochures, along with rolls of white and black paper with water-glued ends that had no apparent objective but to challenge our curiosity.

A few discarded old Garrett burlap patterns, badly damaged by poor inking and later used as clean-up rags, were salvaged from one corner. In retrospect that first somewhat nerve racking and tenuous visit to the factory basement hardly even scratched the surface of what future, less emotional and more studied searches would unfold to our little research team.

With clothes well blackened with a generous portion of the accumulated grime of more than a quarter century, our faces smeared like a swat team from the constant wiping away of dangling cobwebs and imagined lurking spiders and still highly cautious of the electrical hazards in the water damaged sections of the basement we decided to call it a day and regrouped on the main floor to assess what initial discoveries we had made.

Later that evening, after shedding our work clothes and savoring an urgent shower at a local motel we again examined our finds, lamented our premature departure from the basement and realized that we had only opened a crack in the door of an important gateway to rug hooking history. It

was obvious that what we had found must be preserved for future generations.

After a somewhat sleepless night and the realization that unexplored treasures still beckoned discovery we returned to the site the following morning. It was to be the first of many follow up visits we were to make over the next year. To his credit Eddy always welcomed us with a helping hand.

Eventually this persistent searching would lead us to acquire all the remaining factory mechanical equipment in that basement, plus many archival treasures from a century past, which somehow had miraculously survived the ravages of a fire, water leaks, itinerant "pickers", mould, rot and ultimate disintegration. We saved what we could salvage, and were dismayed by what we realized had been lost!

We were definitely not the first, and probably not the last to explore that old factory basement. We learned of Museum experts and researchers, commercial entrepreneurs and antique dealers from Nova Scotia and elsewhere who had visited, investigated, and acquired items. We have found traces of acquired relics as far away as Quebec and as near as Middleton, Canning and Pictou. All collectors, we later learned had missed the true significance and the most important items of a rug art heritage that was in extreme jeopardy of total loss.

Five years before our visit we were told a Pictou County commercial entrepreneur had made repeated visits to the same basement and acquired hundreds of old factory-perforated stencils. Many years later after learning of the heritage treasures she had bypassed in her explorations she threatened to sue us for our finds. The legal fees we paid to defend our

acquisitions against her invalidated claims, have never been reimbursed to this date.

A commercial antique dealer who also intruded uninvited into the basement during one of our searches had to be ordered to leave by the owner when he trespassed into the hazardous area where we were working. Volunteering can be a noble endeavor but saving history in the public interest can have unhappy obstacles and obvious frustrations that the serious researcher must impatiently suffer for history's sake.

The factory building itself is only a vigorous walk away from a major Industrial Museum created by the Province of Nova Scotia some years ago. A community oriented historical house operated by the Pictou County Historical Society along with John Garrett's original New Glasgow home also still survive nearby. The latter hosted our first major exhibit with joy that the Garrett dynasty had finally been honored.

The 1892 Garrett factory itself was certainly no secret to anyone but none of its explorers had been able to discover the mysteries it contained since most such prizes had been lost or forgotten in the obscurity of the passing years. They had also been well guarded by intimidating cobwebs and mould.

Some five cases of documents from that same factory we later discovered are now safely preserved in Ottawa in the vaults of the Museum of Civilization of Canada. How they reached there we are still uncertain. We also learned of several Annapolis Valley collectors and one from Pictou County who had much earlier than us explored that forbidding basement and acquired hundreds of the old perforated working stencils that were scattered throughout.. Lacking

secure heritage protection several hundred of these old stencils we discovered had been ultimately destroyed by a fire after removal from the factory. Such is the fragility of history abandoned to an unknown fate.

One piece of factory equipment a perforating device to permit the passage of ink through those old paper stencils had actually been purchased by a commercial entrepreneur but had been abandoned intact in the basement for over five years before it was finally removed. It was our research team that drew to her attention its possible loss by water damage, fire or theft.

Fire in fact was no stranger to the old factory building having already seared one section in a previous near disaster. That blaze consumed a section of the building where teams of rug pattern colorists once worked. It has been with great difficulty that we have struggled to reconstruct this interesting phase of the factory operation and succeeded in identifying a small number of the women who labored there over the years by carefully reconstructing and analyzing old records and work sheets.

The Real Garrett Treasures Unfold

Had it not been for stubborn persistence in continuing our research in that abandoned basement the most significant discovery in North American rug hooking history may well have been lost to posterity, this time not by fire damage or negligence but as a victim of water and mould.

Our search for artifacts of rug hooking in that unsavory old basement was made difficult by mountains of boxes and

materials of unrelated materials reflecting the later use of the building as an antique emporium. Cast iron pots and frying pans, parts of abandoned spinning wheels, stacks of old records, books and magazines, debris of 100 years were stacked high and interspersed with the rug factory artifacts.

Our detailed search continued for a considerable period and it led us from one grimy point to another, usually without avail. Finally, as our patience wore thin, and with little stomach for our frustrating probing into soggy cartons of musty papers we made the first amazing discovery. One eventful day we found at the base of a foundation support beam, near a leaking water pipe, a large box of factory documents. At first examination it appeared to contain only old records, tally sheets and files of images from old magazines used by the pattern designers as references for their drawings. All of great value for archival preservation-but only a scratch on the surface of what was still to come.

Seemingly reluctant, the box gradually disclosed its real treasure.

Slowly unveiled to us were stacks of loosely assembled original pen and ink sketches which were immediately recognizable as early designs for hooked rugs as each precious piece emerged one by one from the box.

Neither the discovery of a long lost Egyptian tomb nor the treasures of King Tut could have been more rewarding. It was a gift from the past, a visual feast for the eyes and inspiration for the rug hooking soul.

Those hundreds of tiny pieces of original pen and ink drawings had survived for more than a century, had surmounted the insidious attacks of dampness, leaking water,

creeping mould and insects and were laid before us like a gourmet smorgasbord.

John and Frank Garrett had opened their Pandora's box of art to feast our eyes. Had there ever been a moment like this in rug hooking history?

Each delicately drawn image was little more than 4x6 inches in size, sometimes smaller. We had seen printed reproductions of many of them in our earliest research such as were contained in the old brochures that the Garretts published annually. This however was the original pen and ink artwork. We were celebrating an exquisite treasure.

Nothing could diminish the mutual excitement we all shared at that moment as each delicate piece of art was removed and examined. More than 300 immaculate images from yesteryear were rug hooking history's reward that day. The past was speaking to us through the creativity of two early Canadian rug designers John and Frank Garrett.

Although strangers to us, John and Frank must also have shared that moment in time with as we were suddenly united by the twists and turns of fate and through passing generations to each other by their beautiful art.

A fleeting moment in time - we paused, melded together despite the cobwebs dangling between us. Ghostly shadows in the dark recesses of the factory the Garretts of yesterday may have been, but in that historic moment they must have smiled at the knowledge that their work would live on for the joy and benefit of future generations. Even more surprising discoveries were to be made but certainly none to rival this first historic moment.

The Last Momentous Find

Our next discoveries, a double-header, were to be made under considerably better illumination in that same factory basement. We had returned again to complete the search and Eddy MacArthur had upgraded the electrical system since our last visit.

The painstaking research described during previous visits had virtually left no water soaked cartons unturned and on this occasion we were in active negotiation for the purchase of all the remaining manufacturing equipment used by the Garretts in producing patterns for their customers.

Rug hooking history sadly lacks the preservation of such major components of its early heritage as no publicly owned Museum or Gallery of Rug Hooking has ever existed in North America to pursue and preserve such major acquisitions.

The emergence of a basically intact century old hooked rug pattern factory and most of its historic records was certainly a prize for historians of rug making that simply could not be ignored. Lacking public funding we burrowed into our retirement pension funds to acquire what we could and added this major acquisition to the growing collections we already had in storage.

We were amazed that such a treasury of artifacts still existed after so many years. We give enormous credit to Eddy MacArthur's generous help and his appreciation of what we were struggling to achieve, since without his aid and consideration such would probably have been lost to posterity.

Antiquated, mostly home-made, rusty, dirty and decrepit

the tired old factory equipment was viewed by the researchers as a dramatic physical look back into the past of an international rug hooking story which has long been ignored by the great museums and art galleries of the world.

Such experts have good reason to reflect on their oversight and cultural neglect of what could well be North America's oldest folk art. The basic concept of the art had been brought to the continent by our European settlers where it evolved in a new form based on the ingenuity and utilitarian need of pioneer settlement and specific material availability just as had many of its artistic counterparts such as painting, sculpturing and ceramics.

Contemporary cultural gurus were little aware that amidst the glitter of new-found television, computers and the world-wide web that the fine art of "painting with wool" was emerging from the drafty floors of pioneer cottages, rising above the folk-art trend of the 1950's to become the American continents newest fine art form in the 21st century. No longer was the art of rug design destined for inevitable relegation to church and community halls. It was a time of discovery and awakening.

We had at this point acquired all the factory equipment excepting one piece previously purchased by a commercial entrepreneur and are taking advantage of the improved artificial lighting to review basement areas previously assessed in the event we had missed something of importance.

Only one area remained for closer scrutiny. It was at the most remote end of the building where a leaking sewage pipe created a shallow pool of water on the floor and little of value was visible there.

On this occasion we had also returned with a powerful hand-held battery operated torch to facilitate our examination of the equipment and we were now using its penetrating shaft of light to re-examine our earlier trail of discovery when our attention was attracted by a water soaked carton near the pool of water. It was empty, but behind it was a stack of old books several feet high. Leaking water from both above and below made access and salvage wet, dirty, and sickeningly obnoxious to our nostrils.

Removing the upper books, virtually all coated to some degree with medium to heavy mould we packed what we could reasonably retrieve in a green garbage bag. One massive tome we salvaged was an early 20th century German dye book containing color samples which were applied to a number of differing cloth fabric materials to show the varying tones which could be achieved. It was later to prove a challenging task to clean the mould growth from its cover and many more hours of sunshine and deodorizing strips to eliminate the overpowering musty smell.

A true archival prize for modern day dye analysts, it subsequently proved to be worth all the effort.

It was just under this book that we found a small package wrapped in water-stained brown paper which to our delight again spilled out another collection of original pen and ink art- These were mostly identifiable as being hand drawn by Frank Garrett (Jr.). Invigorated by the find and despite the stench of that corner we continued to remove the few other books that appeared salvageable.

Concerned about the very real health hazard from the decaying material and leaking sewage we debated abandon-

ment of our search at this point. We had been physically overcome by the prevailing smell and sick to our stomach. How far can even a history fanatic go to save history? We were to find out!

A Time Capsule of Unknown Art

A thin darkish cardboard container, just an inch away from the leaking sewage pipe made us hesitate about leaving the scene. We went for it!

Breaking a slender string holding it together we opened the lid. Little more than 8x10 inches in size, that insignificant little box disgorged another dazzling historic find of some three hundred more rug pattern designs. This time however they were not pen and ink art.

They proved to be made in the form of tiny brown paper stencils. Each piece was about the size of the pen and ink artwork we had recovered earlier.

The intriguing tiny pieces of what appeared to be a type of wrapping paper had been intricately cutout, obviously by a skilled hand, and it was not until much later perusal did we realize that in some instances they were so neatly designed that two complete rug patterns could be created from a single stencil. In one instance we were able to demonstrate by using a simple computer scanner that four different rug designs could be reproduced out of one 4x6 inch cutout. We marveled at the 19th century technology that challenged our wits for some form of definition.

Here again a fascinating and intriguing story about rug pattern designing was unfolding before our curious eyes.

Little wonder we labeled them the Mystery Patterns-and what a sad loss to rug hooking history it would have been if they had been lost to decay. Who had created such exquisite hand cut stencils, why their miniature size, who was the artist? **Were they possibly the oldest commercial rug art in the world?**

How close history came to losing this totally unexpected and very unique collection of rug pattern art is a miracle. The box we saved had been in imminent danger of destruction. Immediately below it water had so saturated the stack of books on which it had been placed that when we attempted to remove one of them it disintegrated in our hands. Hard covers and pages pulled apart as we attempted to remove them. The fumes and stench were so powerful that we became ill on the spot. Suzanne insisted we give up and at that point I was too sick to protest.

Those miniature stencils were in fact the last major item we recovered from that factory. The difficulty facing us now was to determine how these tiny jewels of artwork inter related with early North American rug hooking history. We still needed answers!

Introducing the Garrett Dynasty

The late John E. Garrett, founder of what was once the largest rug pattern factory in the world (top) demonstrates a perforator he designed to punch holes in multiple sheets of pattern paper to create burlap rug foundations. The circa 1892 plant at New Glasgow, Nova Scotia also gave birth through his design ingenuity, of the Bluenose "speedy" hooker, which sold a million copies and was designed as a punch hook to increase production. The hooked Garrett design (above) was produced in less than a week in this demonstration in a Halifax store's display window in the late 1920's period.

Time for Celebrations

Introducing the 1892 Garrett rug pattern factory (top) all decked out in bunting to await the arrival of the King and Queen of England during their tour of Nova Scotia communities. The old 1800's building (still standing) was not only a rug pattern factory, but at different periods served as a printery, a steam and dye works and more recently as an antique emporium. A proud Miss Claire Garrett (later to become the wife of Hugh Sutherland) poses in this 1930's image with a Scotty dog hooked design created by her uncle Frank Garrett (Jr.) who studied art in New York in the same class as famous American folk artist Norman Rockwell.

18

Rescued from Oblivion

It was a search for heritage in the historic old Garrett rug pattern factory that still held unknown treasures of America's most endangered art form 25 years after it had been closed. Discoveries that unfolded were to amaze researchers and an international rug hooking community. The top image shows the water and mould damage incurred in the old factory basement from where more than 800 pieces of original pen and ink rug art were saved from oblivion. Some of these books were salvaged in the process as was the unique rug hook tumbler used to polish hand made rug hooks in the circa 1892 factory.

Chapter 2

The Mystery Patterns

Back in 1939 Great Britain's Prime Minister Winston Churchill described Russia as " a riddle, wrapped in a mystery, inside an enigma".

His description could as easily have been applied to the evolvement of commercial rug pattern designing we had just discovered in North America in the mid to late 1800's.

Before embarking on the analysis of our startling rug art and stencil discoveries we needed to understand that this period was an experimental and competitive time in the commercial history of rug hooking.

Secrecy was essential as new mass production techniques for rug designs were being sought. Both designs and pattern reproduction methods were sometimes borrowed, sometimes unique. They were being adapted from hand carved wooden blocks for stamping (such as utilized for embroidery designs) to tin plates for screening them and paper sheets for stenciling, hand-carved full sized wooden plates for direct printing and surplus newsprint press cylinders designed to roll them out.

When we made our discovery of unanticipated 19th century miniature artwork in Nova Scotia we had to ask ourselves how such stencils and pen and ink artwork could have been used for this purpose. How indeed were such tiny images of both intricate stencils and dramatic pen and ink designs to become the basis for what was to become the world's largest rug pattern factory?

From the grime and mould of a 19th century rug pattern printing factory in New Glasgow, Nova Scotia, Canada a story emerges which combines all of Churchill's adjectives and more, in a long lost saga about rug pattern design and production that still remains partially cloaked in a foggy shroud.

Documented history has long attributed to the late John E. Garrett, owner of that 1892 factory the distinction of being a key figure in the widespread advancement of rug hooking not only in Canada but particularly in the United States and broadly around the world in the period from 1892 through to the beginning of the Second World War. It has now become evident that the Garrett's had found a production method that was both cost effective and could quickly fulfill a need of potential customers in the rug hooking community.

While the Garrett family's well documented and widespread marketing and sales in Canada, and the United States through almost a century focused publicly around their effective promotional programs, little was said and even less written about how they met the production challenge so effectively. They left it to us in the 21st generation to conjec-

ture and analyze their methods, leaving only sparse hints that have required minute examination to comprehend.

It was John E. Garrett's secrecy about his production methods in fact which created blinders for hooked rug historians and writers who focused on the undoubted business success of both him and his talented descendants, and in so doing missed or ignored reference to the research by his father Frank (Sr.) and himself into replication and manufacturing methods for rug designs.

Researchers who have studied this conundrum in retrospect have discovered that the designer's art in itself provided an insight into the reproduction techniques which were to become an integral part of the company's remarkable marketing success.

The big hint was there for all of us to see, but for none to recognize. The key was recently publicly displayed in a simple image on the Canadian Museum of Civilization website but easily overlooked without the dramatic repetition of its message in our Garrett factory basement salvage efforts. Without finding both the pen and ink drawings and the mystery stencils along with the information about registered Canadian patents the Garrett reproduction method may never have been satisfactorily identified.

Was the answer-Frank Garrett's Patents?

First, John Garret's father, Frank (Senior) in particular has been unkindly ignored in the annals of rug hooking history as well as amongst those who later played active roles in Garrett pattern design and manufacture. Some one must have

been aware of what transpired during those early days but it was kept a secret until the dawn of the 21st century when research helped us lift that veil of obscurity.

The riddle we studied hinges around how and why Frank came to have his name on a considerable number of "patented" rug hooking images in 1894 and why he started marketing them and producing rug hooking patterns for a brief time in his own name.

What reasons led him to patent and market images of rug designs in 1894 when copyrighting is the normal procedure to protect design ownership such? Here was the first clue. Was it possible that Frank was patenting something other than the design? That question started bells ringing both in relation to the paper stencils as well as for son John's pen ink designs.

Why too does it appear that Frank was in competition with his son at the early period of John's venture into the rug pattern production and marketing business? With each question we came closer to the ultimate answer.

We asked Cameron Garrett, Frank's great grandson that question but he was completely unaware of how or why the Mystery stencils were created. Even as the last Garrett factory manager, the secret had been so well kept that he told us he had never before seen those unique stencils

Take a giant step forward into the early 20th century and once again examine the words of Cecil Garrett in his speech given to the New Glasgow and Halifax Gyro clubs in the late 1920's in which he tells how his father John first became intrigued with the art and craft of rug hooking because he

saw a stack of rug patterns for sale in the window of a Halifax auction house.

No historians had ever raised the question until this time as to where these Halifax based rug patterns originated nor who placed the designs on the burlap and replicated them for sale. Most certainly it was not the youth John Garrett. Is it possible they had been designed before he emerged on the scene. We needed to think further out of the box.

Again recall Cecil Garrett's remarks to the Gyro luncheon:

> **"About 48 years ago in Halifax (which would have been about 1879), there was a store on Brunswick street, at the foot of Cogswell street, where there were burlap rug patterns displayed. My father (John E.) used to see these patterns as he went down Cogswell street to work, and strange to say, although he had no inkling of it at the time, these patterns and that store had more or less to do, in an indirect way, with his getting into the business of manufacturing burlap patterns for hooked rugs."** (Cecil indicated a linkage but to what?)

Since the Garretts obviously did not produce these early patterns-then who did? Who owned that interesting store on Brunswick at the foot of Cogswell in downtown Halifax during 1879? Did the owner of that shop produce those rug patterns or were they acquired from a supplier? If so, who?

Cecil Garrett provides us another clue- "The owner of

that store made an assignment (possibly due to overstocking, going out of business, bankruptcy etc) and "the stock was bought by an auctioneer firm Shand, Ferguson and Clay." (the name Ferguson provided another clue.)

The speaker continued: " When this firm started to retail the stock, they were afraid the rug patterns would not sell, and they marked them down, with the result that they were about the first things in the stock that did sell."

Witnessing this marketing success did Ferguson search out the original designer and launch his own pattern business or did he simply buy the stencils from the unknown artist and commence reproducing them himself? Alternatively was he possibly the original designer?

Pre-printed designs on burlap would have been a novelty in 1879 a godsend to rug hookers who up until this time were struggling to create designs on burlap feed bags with such primitive tracing tools as charcoal (burned pointed sticks). The price of a pattern, especially when marked down would have only been a few pennies each and it is understandable that they were a readily marketable item.

The still unanswered question is whether these unique items were designed and manufactured in Nova Scotia and if so by whom? Where they imported? If so, from where?

The estimated 1879 date when the Mystery Patterns were first noted as being sold was just after the renowned Yankee peddler Edward Sands Frost of Biddeford, Maine had sold his rug pattern business (made from zinc stencils) to James A. Stroutt also of Biddeford. Could the patterns in that mid city Halifax shop have been Frost patterns imported from the United States? The answer is highly unlikely as commercial

rug patterns had not been widely distributed at this time, and importation appeared unlikely.

Cecil Garrett also answered that question for us when he noted in his speech: "On one occasion Mr Ferguson (apparently a member of the auctioneer firm of Shand, Ferguson and Clay) who was then only 18 (who Ferguson or John Garrett), when John Garrett went on a trip to Boston, asked him to get a few patterns there from which to get ideas and coming home on the boat, it occurred to my father that these patterns should be printed....."

Based on the request by Ferguson for John Garrett to acquire some patterns while in Boston there appears to be little likelihood that the collection of rug patterns sold by the auction company had been imported. This raised the probability that it was a local artist and printer who created them.

This difficult in tracing one tiny but important component of rug hooking history emphasizes how the passage of time has obscured many significant developments which contributed to the probable beginnings of continental North American rug hooking and mat making in what is historically known today as old "Acadia", a geographical boundary recognized by the Treaty of Utrecht between France and Britain in 1713.

There has long existed a vague and to a degree controversial understanding of the origins of the hand hooking of rugs and mats. It may well be North America's oldest folk art born of European settlement here. Following the introduction of burlap around 1850 as product containers (feed bags), and as European settlement began to flourish along the Eastern

seaboard of New England and Atlantic Canada, discarded clothing and home-spun yarns were being hand hooked into the salvaged burlap to create utilitarian items such as bed coverings ("ruggs") and floor coverings ("mats").

Credible attempts to accurately trace rug hooking from possible European sources to its evolvement in the New World have been made and come up short. Influences of varying forms of needlework along the eastern seaboard of North America, have however been recorded. While working with needles was common far back into history, involving both men and women in producing nets, traps, lace and clothing the closest example to rug hooking as it is best known in North America seem to be more or less related to the crafts of crocheting, embroidery, knitting and quilt making.

Rug making continues to be adapted and also evolve regionally and locally even to this day. A number of talented early North American designers vie for recognition as the first to create commercial rug designs. They range from the late Philena Moxley with her hand-cut wooden embroidery pattern stamps to the creative Edouard Sands Frost who used his "tin peddler" talents to create stencils on zinc plates, in the 1868-70 period. Neither are to be discounted for their contribution but the likes of Kenneth Ferguson and Frank Garrett (Senior) expand the scope of early commercial rug pattern makers and designers who also warrant studied examination of their specific roles in that heritage. Rug art has no artificial boundaries-it reflects the creativity and utilitarian needs of the pioneers who settled our vast continent.

Rug Making Enters the American Scene

While it was the introduction of burlap bags as the container for bulk animal feeds about the mid 1850's in both the United States and Canada which was to became an accelerating factor in the creation of large quantities of hand hooked rugs, mats and bed coverings in America the first designs were of naive styling created from what was on hand by humble housewives to warm the floors and beds in drafty log cabins.

Being utilitarian in nature, very few of these very early examples remain in reasonable condition for public viewing, so Museum authorities have had to embrace replication programs as an acceptable alternative.

The "At Grandmother's Knee" program in 2006-2007 in Lunenburg County, Nova Scotia saw more than 50 such historic rug designs re-created from those original Garrett pen and ink art. They were created by senior citizens who mastered rug making as handed down from generation to generation by their ancestors. The Government of Canada's New Horizon's program for senior citizens helped finance the unique effort to not only create rugs in as close as possible to original form and style but also to train fifty newcomers to rug hooking in the ancestral methods those seniors had inherited. History benefited from both the replication effort in preserving the old images and from the creation of a young pool of new rug hookers who could capably carry on the old traditions.

Quite likely rug making rapidly advanced throughout North America because of the recycling of burlap feed bags

as a foundation material (1850) but recent research is providing new clues into what other materials preceded the use of burlap in the evolvement of the art, and its impact on the design component of the earliest known rug hooking (1750).

Kenneth Ferguson-Mystery Man

Now, Churchill's "mystery inside an enigma" takes an interest new loop in the interpreting of rug hooking history. The mystery as recounted earlier relates to who designed and created those early rug patterns being sold in downtown Halifax and the enigma is applicable to the connection between Frank and John Garrett and the gentleman named Ferguson.

According to Cecil Garrett's speech, the mystery-man Ferguson (later to be identified as Kenneth) **" was more or less an artist and he made some more patterns and they sold"**. This simple line leads one to ask what does **"more or less an artist"** actually mean? Is it because he was mediocre in creative talent and drawing skills, does it mean he was simply an opportunist who seized on a chance to create a rug pattern business or just possibly was he adept with a knife and scissors and had an artistic talent for doing cut-outs which could be used as paper stencils? Had he read about Edward Sands Frost's creation of zinc stencils and decided to emulate the technique on paper or was there a third party whose identity as a stencil maker still remains hidden?

A critical question is whether Ferguson himself was the original producer of the rug patterns that John Garrett had spotted in a store window while walking to his father's fur-

niture and wood-working shop. The answer may be found in the next phase of this enigma when it first came to light in the late 1800's - not in downtown Halifax however, but some 150 miles north-east in New Glasgow, Nova Scotia,

Frank Garrett (Senior,) woodworker and furniture manufacturer (the father of young John Garrett) decided to move from Halifax and seek new opportunities for both his business and his family in the bustling and prosperous industrial town of New Glasgow, Pictou County.

As Cecil Garrett described it: "Later on this man Ferguson moved to New Glasgow and opened a store next door to my grandfather's furniture store, where Vineberg and Goodman are today.(1927) He still continued to make rug or mat patterns for his retail trade, and any surplus stock he shipped to Halifax. These patterns were all made with stencils."

This statement now provided a significant insight for the research team. Ferguson's relocation raised eyebrows but this was the first specific reference to those early rug patterns as being made directly from stencils as the reproductive method for mat patterns. It had escaped initial attention until another remarkable discovery emerged.

The Garrett-Ferguson Contract

The contents of that small box of cutout components of rug designs recovered from the Garrett factory basement were undoubtedly all stencils.

Was this finally the key to our discovery? We pondered Cecil Garrett's quoted remark that Ferguson was "sort of an artist". Reviewing the facts before us we had obviously re-

covered an impressive mass of very finely cut stencils which had taken months, possibly years to create. This artwork was no mean feat in itself but it does appear that stencil cutting at this period in time was considered more a craft form than an art. Than there was the intriguing issue of the designs themselves, requiring an artist's mind to formulate and a technicians to implement. Cecil seems to have accurately pinpointed the Ferguson involvement as being "sort of an artist" in quite accurate terminology.

But more validation was unfolding, this time appropriately provided by Claire (Garrett) Sutherland, daughter of the same Cecil Garrett who related the Garrett history story to the Halifax Gyros. Her disclosure was even more momentous- a copy of an original contract signed by both Frank Garrett (Senior) and his friend Kenneth Ferguson in 1895 in which Ferguson sells all his "stencils" and rug pattern equipment to Frank Garrett.

We let the contract speak for itself:

Agreement Between Frank Garrett (senior) and Kenneth Ferguson

New Glasgow, 15 Oct 1895

" This is to certify that I Kenneth Ferguson have sold out my business of stamping or stenciling patterns for hooked mats or rugs to Mr Frank Garrett of New Glasgow, N.S.

Which sale includes the goodwill, stencils, brushes, dyes, and other articles which I may

have on hand, which I used, or which are necessary for making such patterns;

Also I agree that I will not engage or have anything to do with the making of rug patterns in any way, either alone or by my assistance either financially or otherwise with anybody else–under a penalty of five hundred dollars.

In consideration of which Mr Frank Garrett agrees to furnish me with sixty dozen mat patterns size 32x63 inches by December 1st, 1895.

(This agreement, all in longhand, is signed by Kenneth Ferguson and Frank Garrett.)

Production of 720 rug patterns, quite massive ones requiring 15 square fee of burlap for each one would have placed a heavy and immediate production burden on Frank Garrett's shoulders unless some mass production technique was available. Further, the period from mid October to the end of November left him with only six weeks before he had to produce such a quantity. There had to be a production secret.

The dating of documents at this juncture provides another clue along the long road of research. The 1895 date of the Ferguson-Garrett contract becomes particularly significant when related to other materials we uncovered in that old basement.

For example, we found several accordion pleated fabric-backed binders containing a series of mechanical half tone

reproductions of rug pattern images. Alarm bells rang when we examined those images.

Each bore the word Patented 1894, along with the name of Frank Garrett, New Glasgow, N.S. We could hardly believe our eyes– was a new designer emerging here?

Ultimately a very early printed flyer, not by John, but again under the banner of Frank Garrett, (Sr.), came to light offering for sale 21 different hooked rug patterns, all Patented 1894, and each bearing Frank's name. Each was reproduced in half-tones, most finding matches in our collection of small paper stencils recovered in our factory research. What were we to make of this appearance of a previously undisclosed rug pattern distributor and possible designer?

Were the images in that 1894 flyer adapted from whatever stencils Kenneth Ferguson sold Frank in 1895 or where they his own work? Could they have been created by John Garrett? If the stencils were the work of Kenneth Ferguson or his unknown designer, how did they come to be patented by Frank before he actually acquired them under the contract agreement a year later?

(Questions pile upon questions and few answers are available!

Canada's Museum of Civilization Web Site

(In an examination of early catalogue marketing methods used around the turn of the 20th century, this site related a brief history of early Garrett factory marketing and included an illustration of an old rug design. Unfamiliar to us, It appeared to carry the same "Patented in 1894" date only this

time bearing John Garrett's name rather than that of Frank. What was going on here?

It was the Canadian Copyright office's Tom Bird who before his retirement from that Canadian government post went out of his way to help us examine what copyright records existed for John Garrett's endeavors. Puzzled like us over the use of the word Patent on the artwork he surmised that the Copyright identification applied to written material or images while the word Patent applied to manufacturing processes.)

It was not until we again carefully examined a Garrett advertisement that we finally realized that what both Frank and John's images were telling us was their work was being reproduced in a distinctly different manner. **Bingo!**

Consider this quote from an early Garrett flyer: "Our patterns are all printed from blocks, by our patented process" That early "patent" reference was clearly pointing to the process not the art itself. (We had been blinded by that miniscule variation in meaning).

The other questions of importance still remained obscure, the artist and executor of the stencil designs and the method of process itself as well as the apparent discrepancy in dates between the published advertisement and the Ferguson sales contract, remained hidden.

History was not easily giving up its secrets !

FIRST MYSTERY RUG DISCOVERED

Less than 10 percent of heritage hooked rugs can be identified by either their maker or the year of creation. Dates hooked into old rugs can be misleading as they can reflect later celebration of historic events. When researchers found some 350 hand cut 4x6 paper stencils acquired by Frank Garrett (Senior) from Kenneth Ferguson they were designated Mystery Patterns as their creative origin remains unknown. Research hints indicate they may have been made in New Brunswick. The first validated Mystery rug was found in the home of Sheila (Knowlton) McRury in Chester in 2008. It was made by Sheila's late grandmother, Lottie Briggs of Fredericton , N.B. (framed image). Mrs Knowlton and Mrs McRury are shown holding the first original found.

OLDEST KNOWN DESIGNS

The three Mystery design stencils pictured here are a few samples of the more than 300 oldest known commercial rug pattern designs in Canada. A search continues for their possible designer who would have been born in the early 1800's, They were purchased in 1895 by Frank Garrett (Senior), New Glasgow from a former auctioneer Kenneth Ferguson formerly of Halifax. No larger than 4x6 inches, most examples contain 2 complete rug patterns by flipping the quarter designs shown in four different directions. Origin date estimated circa 1850–1875 period.

NEWCOMER TO RUG HOOKING HISTORY

Loss of early North American rug hooking history is high-lighted as an unknown figure emerges with the name Frank Garrett (Sr.) being identified a century after his death with the discovery that he had purchased some 350 tiny hand cut stencils in 1895 . The oldest commercial rug designs ever found in Canada their actual creator is unconfirmed. Frank Sr. not only advertised and printed marketing material but a year earlier he also patented (see inset) a new processing technique, to accelerate mass production.

Chapter 3

"After drawing her design on the burlap, the next thing was the material of which the rug was to be made, She would go through her rag bag in which for months past she had been storing all kinds of discarded clothing, blankets, hosiery, underwear etc. Some would be used as they were, others had to be dyed." (The New Glasgow Evening News)

Father and Son Partners or Rivals?

The Garretts of New Glasgow originally had direct Lunenburg County lineage and used the Gerhardt surname. It is noteworthy that the Gerhardt family name still appears in the social and business life of the world famous UNESCO heritage site of Lunenburg, a Nova Scotia coastal town which today in 2010 still reflects a sea-faring heritage dating back some three centuries and a unique architecture, some of which survives from the late 1700's. However, Gerhardt changed to Garrett when Frank (Senior) relocated to Pictou County with its substantial Scottish population.

Unlike those 1750's Lunenburg settlers who came to

be known as the Foreign Protestant immigration (because many of whom were escapists from persecution as followers of Martin Luther), the Gerhardt family moved to Nova Scotia from the United States around the time of the American revolution (circa 1773-1776). While not considered to be Empire Loyalists they arrived in the province on their own volition, where they started a new life along the southwestern shore of Nova Scotia (Liverpool), and later in Halifax and New Glasgow.

The earliest identifiable Gerhardt of this family to be recorded in Nova Scotia was John George. His wife was Annie Barbara McGeorge, she died Jan 5, 1891 and is buried in the cemetery at St Luke's Anglican church in Liverpool. Two children were born to John and Annie in the persons of Frank and Agnes.

We necessarily designate this specific Frank as the senior of this unique family of hooked rug pattern designers (for the sake of clarity) as he was later to boast of a young grandson bearing the same first name and who was also to contribute substantially to the family's unique role in North America's rug hooking heritage.

Frank, the senior Gerhardt, was born Aug. 21, 1839 and survived until July 3, 1912. His wife Agnes (Bonnyman) of Tatamagouche was born Nov. 3. 1838 and died May 14, 1895 in New Glasgow. (See detailed family genealogy in Appendix).

We do know that Frank was a furniture maker and upholsterer, working for a period with Cumming Brother's Furniture factory in Halifax before opening his own small furniture making shop in downtown Halifax where his son

John E. was also to work alongside his father as a young boy.

This enterprising Frank eventually decided that greener pastures existed in the bustling industrial town of New Glasgow in Pictou County where he relocated his business along with his young family in the late 1870's or very early 1880's. His relocated family included son John Edward, about 14 years of age at the time, and his daughter Mary. He appears to have worked as a finish-carpenter in his first couple of years in New Glasgow.

Conjecture about the Garrett's arrival date in New Glasgow was narrowed down when it was learned that one of his early tasks as a furniture builder on his arrival in New Glasgow, was to create the caskets for the some 44 miners who had died in a gas explosion at what was known as the Foord Pit. That tragedy occurred the 12th of October 1880. It has also been established that Frank Garrett (Senior's) furniture business commenced operation in 1882 based on advertising in 1900 data when he closed down his furniture shop and concentrated on the sale of patent medicines.

Earliest marketing of a patent medicine by the Garrett clan was evidenced in an 1894 letter home from Yarmouth written by John to his father. When Frank "retired" he had advertised that he had "sold of his stock (furniture) and re-moved this week to a store near the station where he will devote his time to the manufacture and sale of Manoleate soaps, a thing that is taking the market very rapidly!"

Following their arrival in New Glasgow Frank (Sr.) and his family changed the spelling of their family name from Gerhardt to Garrett. The exact reasoning for the change is

unknown but family conjecture is that the Garrett spelling was more compatible with the Scottish names that pervaded the Pictou county area at the time rather than the more guttural sounding Gerhardt. According to Cameron Garrett other members of the extended family however still retained the Gerhardt spelling.

The move to New Glasgow did not, initially reflect a major change in Frank's work of furniture building and upholstering but it does appear based on marketing evidence that he launched a furniture sales outlet with some innovative and non-related products and that he utilized for the times some quite creative advertising.

Word soon circulated that Frank's son John had a flair for drawing and people started visiting the furniture shop to have him draw designs on burlap feed bags they had salvaged for mat hooking.

Also intriguing was the almost simultaneous move by Kenneth Ferguson, the Halifax auctioneer, to relocate in New Glasgow, where according to Cecil Garrett's speech to the Gyro clubs "He opened a store next door to my Grandfather's furniture store, where Vineberg and Goodman are today (1927. It is important to remember that Ferguson still continued to make mat or rug patterns for his retail trade, "These patterns were all made with stencils."

Much of our authenticated research appears to conflict with an article by Thomas Lackey titled **Image Sources for Bluenose Hooked Rugs**, published April, 1980 in Canadian Antiques and Art Review. It states: " In a talk delivered to a Halifax service club in about 1925 John E. indicates that his first inspiration to make mat patterns came with the pur-

chase, by a store in New Glasgow, of a lot of printed burlap patterns being auctioned at a bankrupt sale in Halifax .The new owner did well with the patterns and asked John E. to produce a few new designs for him. While it is impossible to know now what the origin of those first patterns might have been, it is not unlikely they were Frost patterns."

Note- (***Researchers discounted this information as lacking substantiation from any reference point and because some of the information did not coincide with other known facts such as Cecil Garrett's first hand, documented speech and John's trip to Boston where he had acquired samples of patterns for Kenneth Ferguson.***

Lackey appears to have been confused about the actual details of where John first spotted rug patterns. Cecil Garrett's more intimate family background would weigh authenticity in his favor. (This conflicting data is included herewith to show how various versions of a story can easily mislead researchers seeking definitive answers)

Should one assume that the relationship between the Garrett family and Ferguson was as good business friends who saw opportunity beckoning and decided to build a new life in New Glasgow, or was their dual relocation merely coincidental? The fact that Frank Garrett and Kenneth Ferguson located their individual business ventures side by side in their new environment indicates that such a decision was more than mere coincidence. As events were to unfold in the ensuing decade, such an assessment appears to be reaffirmed.

Just how this close relationship evolved is obscure, but it more likely developed as a result of the young John E. Garrett's observation of burlap rug patterns in a downtown Halifax store as he walked to his job as a furniture builder's apprentice. Was his curiosity about the creation of such rug patterns so intense as to lead him to make contact with Kenneth Ferguson- a contact which would lead to such great challenges and achievement in the days ahead?

Cecil Garrett's Gyro club speech again links the young Garrett and Ferguson in a further reference "On one occasion, Ferguson, who was then only eighteen, commissioned my father (John E. Garrett), when on a trip to Boston, to get him a few patterns there from which to get ideas, and coming home on the boat it occurred to my father that these patterns should be printed" (Grammatically confusing, the age of 18 probably applied to John, not Kenneth Ferguson). Interpretation of this quote is also subject to cautious scrutiny. Research on Ferguson's age indicates he was well past 18 at that time. Such an assumption would then automatically place John E. as a resident of New Glasgow at the time the request was made since he was 14 at the time of relocation from Halifax). Kenneth Ferguson and John E. were apparently working side by side in abutting shops indicating they probably had become close friends, particularly as John's interest continued to grow in the process of design and pattern making.

It was a natural step in the thought process by John, on his return by boat from Boston to Halifax with the precious rug patterns requested by Kenneth in his possession (quite possibly some of the work of Edouard Sands Frost)

that he would analyze how they were reproduced. He was most likely unaware of the use of metal stencils to create the Frost patterns and it leaves open to serious analysis just who created the earlier Nova Scotia patterns being sold in Halifax by Ferguson. Were in fact our so called Mystery pattern rugs being made from the paper stencils- or could they have originated from some other source? Here we have the mystery wrapped in an enigma so explicitly described by Churchill.

Again, Cecil Garrett's speech offers a clue to the "patented" images we found. "So when he (John), arrived home, (from Boston) he jig-sawed a scroll out of basswood, rolled an ink roller over it, and placing a piece of burlap on that, rolled it with a metal roller for a weight, and it was a success and we have been making rug patterns ever since."

This remark opened the door to a process something akin to a wood stamp and reflected John's carpentry experience in his father's furniture shop. The availability of rare and expensive basswood as well as the tools to cut out the scrolls was very likely. (However, the dating of John's voyage to Boston is useful in establishing exactly how, when and where it all transpired.) The Museum will display several historic old carved wood stamps found in the factory. Their very existence validates Cecil's statement.

One should note that there is no reference at any time to John E. having cut stencils by hand for pattern making. On the other hand we found patterns created on a wooden base using strips of leather or linoleum for definition of designs, during our Garrett factory research, that could well be the first he actually created. (They are also destined to become

part of the exhibits of the Hooked Rug Museum of North America).

Recovered artifacts from the factory such as these carved and lino or leather stamps, old press rollers, and ink stained paper stencils appear to reflect a variety of experimental methods of pattern making by the Garrett dynasty.

Cecil's words do provide validation that John E. was already thinking "out of the box" about how the production of rug pattern designs could be advanced beyond the laborious and time consuming process of hand tracing each piece. He was undeniably the leader in seeking a more productive and economically feasible method of mass producing patterns,

Father and Son -Team or Rivals?

Historic information is sparse about the early days of the Garrett's evolvement in rug pattern design, production and marketing, and particularly lacking in any definitive information on the persistently advertised statement that John Garrett was in operation in 1892.

We failed to find any written or printed documentation available between 1892 and 1894 about the Garrett rug pattern business at which time Frank's "patenting" of rug patterns first came to light.

Exactly what happened in the two years between the alleged 1892 startup date remains uncertain.. The period from 1892 to 1894 was apparently developmental and may have been the period that John was working quietly behind the scenes at his New Glasgow home drawing pen and ink im-

ages for rug pattern designs and experimenting with the best methods to replicate them for marketing.

What does raise questions and doubts about the creative responsibility for at least some of the designs however is the formally recorded series of intricate rug pattern designs patented in 1894 which are attributed to Frank Garrett (Sr.). Was this an indication that there was some sort of a disagreement or falling-out between father and son? Consider what the research uncovered.

Salvaged by HRMNA researchers from a moldy grave in the old Garrett factory was a series of reproduced images of rug patterns, specifically designs No.'s 17,14.13,12,11,10, and 9. Each image was mounted on a black cardboard foundation which in turn were assembled on a single fabric strip which folds into an accordion format for ease of viewing and handling. Each of these images has a designation on it which clearly states: " Frank Garrett, New Glasgow, N.S." On the top of each image it states "Pat.1894 and a number as designated above.

As the boxes and bags of ragged and foul smelling documents were carefully unpacked cleaned and examined by the Museum research team a further similar binder of early rug pattern designs appeared. It was also pleated and mounted on a matching black base. Here again we were to find the Frank Garrett designation on one end of the specific design and the same "Pat." designation and 1894 date on the top.

In this later folder we discovered Pattern No's 8, 6,5,4,3,2 and 1 along with six smaller mechanically reproduced images which were identified only by letters A, B,C, G and H. A picture was emerging here which obviously did not concur

with recorded history of the Garrett operation and seemed to indicate that a previously unidentified designer may well deserve some degree of credit in the annals of history.

The assumption that the abbreviation "Pat." refers to the process of patenting an invention was the first reaction of researchers who unfolded the collection and who immediately requested a meeting with Tom Bird (since retired) of Canada's Copyright agency who researched our conclusion and provided researchers with substantive evidence about the patenting of the successful Garrett Bluenose rug hooker device but found nothing relative to the images which in themselves would normally be a copyright item rather than a "patenting" procedure. He concurred that such suggests implications of a process used rather than as an image being protected.

If patenting was not the meaning of the imprinted reference what was its significance? The date 1894 was undeniably recorded along with Frank's name.

Had these images been created by John Garrett why was he not so credited? Had this become an issue between father and son as some suspected?

Interpretation was at this point redirected to the meaning of "Pat." and the conclusion arrived at by researchers was that the reference signified the process of a reproduction technique possibly used by Kenneth Ferguson prior to his sale of the stencils to Frank. Such a decision led indirectly to the belief that Frank may have simply taken the patenting action to protect his acquisition of the stencils. It should be noted that John Garrett also obtained a patent in 1894 for his process of stamping designs on burlap as indicated in a Mu-

seum of Civilization image displayed on its web site. Were the two men patenting two different processes?

Otherwise, would not the images bearing the Pat. designation by Frank Garrett been in direct marketing conflict with that of son John?

Alternatively, could Frank indeed have patented a different mat pattern reproduction process than son John? Such was deemed possible. Observation increasingly led the research team to believe that two different reproduction methods may have been utilized by the father and son and that the processes were separately patented by each. How could reproduction techniques be so different as to require separate patenting? Those questions were to be ultimately answered-with a surprising result.

What New Techniques Could Be Used?

Since Hooked Rug Museum studies could now confirm without doubt that both Frank (senior) and John E. Garrett were officially on record in 1894 as patenting rug designs this discovery now turned to a search for what possible two techniques may have been available to produce rug patterns from an art form never before used for such a purpose. John's "patent" which was confirmed by detailed documentation on Canada's Museum of Civilization website titled Before E-Commerce "A History of Canadian Mail Order Catalogues, (an item written by Scott Robson ,Nova Scotia Museums) would have necessarily been based on reproducing the miniature pen and ink drawings into full sized rug pattern designs .

Based on the assumption that Frank Garrett (Sr.) obtained possession of the group of tiny hand-cut stencils we discovered in the old factory through his buy-out of Kenneth Fergusson, it was likely that because of them being cut-out stencils, rather than drawings an entirely different process would have been necessary to produce rug patterns. Indication that such a process was indeed viable and efficient confirms not only the patenting assumption but also the source and type of stencils he acquired. The picture was gradually becoming clear.

Reconstruction of the Garrett story suffers from the prior death of most of the key participants involved in creating that history, fading memories of the survivors, and a combination of disintegrating materials and dispersal of much to the four-winds. Thanks however to the initiative and preservation instincts of both Cameron Garrett (son of Frank Garrett (Jr.) the key artist and designer), the last surviving Garrett manager of the factory and his cousin Claire (Garrett) Sutherland-the surviving daughter of John's son Cecil, who has been a significant supplier of historic photographs and documentation for this family history- the researchers have been able to gain insight into important aspects of that hazy historic period of rug pattern design in Canada.

The discovery of three important hand-written documents bearing the signatures of the principals involved at this crucial time in the making of rug hooking history, answers some important questions and indirectly raises a few others.

A Historic Contract comes to Light

Claire Sutherland (grand daughter of John E.) provided us with the first very significant document- the hand-written contract between Kenneth Ferguson and Frank Garrett (Sr.) John's father as reported in Chapter 2. She grew up in New Glasgow and as a child recalls playing in the rambling old Garrett factory building. She had a particular fascination for the intercom system which connected operational areas of the factory. Her father Cecil was both the office manager and coordinator of the company's business operations. Her cousin Cameron Garrett, the last surviving Garrett to manage the factory (son of Frank Jr.) also remembers how the two youngsters would chat with each other over the plant's internal communication system.

Disclosure of the previously unknown Ferguson stencil sale contract preserved in her father Cecil's scrapbook came as a surprise to all- particularly to Cameron Garrett who in his earlier years was plant manager. When apprised of the discovery of some hundreds of intricately cut out paper stencils amongst the water and mould damaged documents he had admitted being totally unaware how or by who such items had been created. He had never seen them amongst the old factory records and was at a loss about how such tiny cut outs could have been used in rug pattern manufacture.

As reported verbatim from the original contract (see Chapter Two) between Frank Garrett (Sr.) and Kenneth Ferguson, the documentation is of such importance that it could transport the history of Canadian rug pattern design and commercial marketing back to the mid 1800's and quite

possibly parallel or rival the period during which Maine's tin peddler, Edouard Sands Frost was cutting similar designs out of recycled tin.

This startling disclosure stunned researchers as well as historians as it unveiled a totally new picture of the Garrett family involvement in Canadian rug design. In just four hand-written paragraphs it places the Kenneth Ferguson stencils clearly in possession of Frank Garrett. The issue was whether the several hundred paper stencils recovered from the Garrett factory basement were the same stencils Frank had previously acquired from Kenneth. The clue provided by the early patenting actions of the two Garretts seems to confirm without doubt that Kenneth Ferguson or one of his associates was the artist who created them, possibly even passing along the unique processing methods.

It opens a further question as to the possibility that even if this amazing collection of stencils was not the work of Kenneth Ferguson then who if not him was the artist who created them? Could it have been an unknown individual working quietly behind the scenes for Ferguson?

Even more complicated–were the stencils referred to in the contract other than those we found?

Puzzling is that the "contract" is dated a full year after the date on the two files of Patented rug pattern designs carrying Frank Garrett's name in 1894. This adds further fuel and reaffirmation of entrepreneur Frank (Sr.'s) eligibility for a degree of recognition as the founder of a dynasty previously attributed only to his son John. Here we are also faced with the possibility of a fourth creator of these art creations.

The unknown details behind the contract agreement

between Ferguson and Frank Garrett (Sr.) raises other questions. Was the contract between the two men achieved in confidence or was John E. a knowing participant in the arrangement? Could it have simply been a gesture of goodwill by Frank to purchase the business interest of an aging friend who desired retirement for health or other personal reasons?

Or, could it have been that father Frank was acquiring the Ferguson business independently of his son (who was struggling to support a recent marriage and new born family and would have little resources to make the purchase)? Could there have been a temporary falling-out between father and son with both men determined to proceed on their individual initiatives?

The waters were also muddied a bit more when Canadian Living Magazine (Oct 31, 1987) printed an article by Anna Hobbs along with a Garrett pattern of The Three Bears (the second best selling Garrett rug pattern design). A section of that particular article specifically addressed the question of a split between Frank senior and son:

"John's father, Frank Garrett was an upholsterer and furniture dealer in New Glasgow, N.S. John, who had an artistic bent, worked with him. His first interest in making mat patterns came probably in the late 1800's with the purchase of a bundle of printed burlap patterns auctioned off at a Halifax bankruptcy sale.

When these sold out, he was inspired to try his own hand at designing. Quick to recognize his talents, the townspeople would bring in old burlap feed bags on which John would draw a design for a hooked rug. Equally quick to see a busi-

ness opportunity John began to produce and sell rug hooking canvasses and supplies. The decision caused a split between father and son because the elder Garrett felt that drawing on burlap was a passing fad, not to be taken seriously and certainly not equal to the business of furniture making." (There was no corroboration of this statement, nor any validation provided. It differs substantially from Cecil Garrett's speech given to the Halifax Gyro club in 1929)

We may never know the answers to the foregoing however doubts must arise over its accuracy when compared to the account given by Cecil Garrett in his Halifax speech now on record in Nova Scotia's Public Archives). Just a year later in hand written letters from John to his father there is shown an obviously friendly and very closely related business relationship between father Frank and son John which seems to negate any serious falling out between father and son.

Thanks to a contribution by Cameron Garrett we can now for the first time reveal two previously unpublished letters recovered in the attic of the Garrett's New Glasgow home in 2006 while they were making repairs to a leaking roof. This correspondence by son John to his father Frank in those early days of rug pattern design establishes concrete evidence of actual joint marketing of mats and or patterns by the father/son combination. The letters virtually eliminate any serious "falling out" between the father and son as was conjectured in the magazine article.

The hand-written letters, of which the research team holds the originals as a gift from Cameron Garrett were mailed by John a year after the Frank Garrett (Sr.) and Kenneth Ferguson contract for the purchase of stencils became

effective. They were written during what at times was a lonely, frustrating and somewhat humorous 400 mile horse and buggy marketing trip around the south-western shore of Nova Scotia. It was a marketing venture which would have taken John E. his dog Chief, his horse Charlie and himself on a "waggon" ride over dirt roads from New Glasgow, to Windsor Junction, Halifax and eventually via the old stage coach road from Halifax to Chester, Liverpool and eventually to Yarmouth, returning via Digby, Kentville and Windsor to New Glasgow.

Voice from the past!

The first letter is written from Yarmouth to John's wife Laura and is dated October 28, 1896 almost exactly a year from the date Frank had purchased the rug pattern business from Kenneth Ferguson. The spelling and phraseology is verbatim.

"My Dear Laura. Oct 28, 1898 Wednesday evening

"Just think, before I get away from here in the morning I will be a week away from home. Saturday was a very nasty wet day but ever since has been beautiful. When I came I thought one day would do me here. I thought it would only take me that to go round but it took all day to fix the waggon.

"Then on Monday I went around trying to sell mats and calling on druggists, then I started

in to try and sell castor oil, sweet oil essences and Guan (?) and Cigars. Didn't sell many but was at it until bedtime. The druggists thought it would be a good idea to paint some and they had a good word for Pam's Balsam so I got some paint and painted all day Tuesday and this forenoon. This afternoon was packing up till it was too dark to see and in the morning I have a barrell and 5 boxes to ship ahead of me to Digby and a barrel of old bottles and box of worm candy to ship back home and sample case of candy and William Archibald's clothes to ship to Halifax.

"Tell grandpa to put barrell and candy in old kitchen and don't open them as the duffers might get among the worm candy. What I am going to do with all the stuff I do not known. I suppose when I get to Digby I will just have to ship again. I do not sell much of what is now on waggon.

"I sold some goods for cash but I need it all as I have yet to buy a cover for my knees and I bought a revolver today, altho I don't expect to need it. Also spent quite a bit for paint and brushes. It is the wrong time of the year and I don't feel like staying any longer or I could make some money painting signs and show cards here, but I believe I could do well in small towns and make a lot of my expenses up in that way.

"Well I am finding it hard to write as the boarders are gabbing. I am writing in parlor. How is everything going. Has Cass turned up yet and are you all feeling well? I want you to write me to Digby even if you have already done so. I will get no word from home I suppose until I get there before first of the week. I would have to go too quick.

"It seems long but I suppose it is my fault for staying here so long. I suppose I should have told you that in case of anything going wrong you had better write or telegraph in care of Mr B. Titus so if I am away he will try and get me. I hope it will not be necessary of course. I mean while you are in doubt where I am and this side of Digby because it would be no use sending to Mr Titus after I got past Digby. I will likely write or drop a card nearly every day I am on the road.

"I think I have got the load in waggon down so it won't be too much for the horse and the dog goes wherever I go now. Today when I came to stable at dinnertime one of the men said I must have been working handy town for "Chief" came home and went back again to where I was working.

"I take a light express and Mr Archibald's horse

round with me when painting. I will carry paint along with me now since I got the brushes. Yesterday "Chief" pulled a girl off a bicycle and tore her dress. I got in trouble for painting on Exhibition fence without asking and the horse got his bridle loose some way where I had him tied and it came off or rather the forehead band got back of his ears and he tried to run. I don't know what I would have done if the bit had come out of his mouth–I got a man who was riding a bicycle to get off and hold him till I got out, There was a dish of blue paint upset over in the waggon and got on the wheel of the waggon and the wheel sprinkled it on the back of my coat and I spent the evening cleaning it off the waggon with benzene and am going to paint the inside of the body of waggon. So, you see I am having a lovely time.

" I wish though I had one of the duffers with me I think one of them would get along fine and be good company for me. I do hope I will have fine weather it has been great ever since Sunday. Well I think I will stop for tonight. I must try to write to Eliza one of these evenings. I won't wind this up till morning in case I think of something else.

"Well, here it is Thursday morning and prospects of another fine day. I have been up and had

a shave and straightened out my stuff-took me near as long as starting from home but after this I guess I will keep everything in the waggon except my blanket and nightie. The nightie is fine and warm and I have used the blanket first few nights but the last few have been warm. Likely I will drop a card tonight or tomorrow. I guess the stuff I ordered grandpa to ship to Windsor Junction I will have mats go to Digby and medicine to Kentville- but ain't quite sure yet. Well I guess I will stop and with lots of kisses for Artie and Frank and Katie , and yourself too,. Also give my love to Grandpa and Mary and George. I often think of you all but had scarcely had what I could call a home-sick fit yet. Hope I won't because I must get used to it. Well this will be my first day on the road with team. I really don't feel much like starting but hope it will be good for my health. I suppose I ought to cut the trip short in case we should do some more this Fall.

"Well Good bye for this time, my dear. I am ever, your loving Buzz"

This "letter home" was written in the late Fall, not the best time to be traveling by horse and "waggon" along the unpaved and dusty rural roads of rural Nova Scotia while trying to market patent medicines, some mats (probably patterns) and painting a few signs to meet the expenses. Such

was the difficult and as poignantly described, lonely life of a peddler at the turn of the century. Seldom do we have a chance to read the tales and adventures of one of them as expressed in their own handwriting.

We are unsure what is referred to as "worm" candy. While it sounds relatively unsavory it could be a reference to a Christmas treat once known as "ribbon" candy, a sugary concoction, possibly made in the old Robertson's candy factory in Truro, through which John Garrett would have passed enroute to the south western shore of Nova Scotia. The apparent need for John to purchase a revolver was also surprising.

The humor of John's devastating last day in Yarmouth was probably not as evident to him as it was to us. The references to patent medicines were interesting because it indicates just how diversified was the Garrett stock and at what an early stage they embarked on marketing these and other productions through a company they named KDC and which was eventually to become a mail-order sideline.

The references to "grandpa" in John's letter is probably identifying Frank (Sr.), John's father- who, because of John's growing family probably became commonly referred to as "grandpa". John's own grandfather would not have been alive at the time of writing.

The next (and only other recorded letter in John's travels around the south western end of Nova Scotia) is addressed to Frank, John's father. It gives us a glimpse into the challenges of communication and logistic problems in launching a new business in that era and also eliminates any doubts that father and son were not working as a team.

Dear Father Digby, Tuesday morning 3rd Nov.
1896

"I arrived here last night, rather late and am
just going to write a few lines to catch the mail
which closes about 11 and it is near 10. I think I
will stay here today and possibly part of tomor-
row and paint some and tack up some cotton
signs.

"I am well pleased with the lettering on cot-
ton signs- letters are good shape too. Might be
a little further apart, that is a little more space
between the two words. I think I would print
them on the same cotton as I think it will stand
better besides being half the price of the other.

"I don't think I would allow Wilson to bind us
on prices to retail as I found his mats here have
sold in some cases in very small quantities at a
much lower price. One man claims he bought a
small lot at 17 cents each- 1 1/2 yards- that is
$2.04 per dozen, but I think price would be all
right on large quantities. I have sold some few
mats for cash at $2.60 -am selling on commis-
sion at $2.80. The people all along the shore
here favor St. John as they get goods across by
water.

"There is no word here from Mrs Archibald so I
cannot tell what the trip will be from this view

but likely I will do shorter distances in the day for I had a picnic last night.

"It got dark and I just had to let Charlie (his horse) go his own gait and pick the road for himself for I couldn't see the road at all times. I lit matches to show other teams where to pass me. I don't imagine I will want any more goods shipped to me unless it is mats or cotton signs. I forget now where I told you to ship some mats but I think it was Kentville or Windsor Junction. If I order any more mats you can work in the old 21's (probably a reference to design numbers). I should have kept a memo of what goods I told you to ship. If I told you to ship mats to Windsor Junction you better drop Mr Harris a card when you get this, to ship to Kentville.

"I have scarcely left out any Bitter cough syrup or Liniment but I think I am doing good work for mat business. Not doing very much advertising for "Pain Balsam", but the dealers will put up anything we mail them and I am keeping a memo of their names.

"I will likely write Mr Coombs. I will also try and write something for the Toronto Litho Co. What about Dick Ridout's ferfar (letter)(?). Ask Miss Fraser's opinion of the quality and if it is alright hadn't you better place another order

with them to be delivered in January if possible?
Did they say anything about the folding of it.

"How are you getting along financially?

I am going to send $25. in this if the bank don't
keep too much off the dollar in Am (american ?)
money I have lots of it from cartwheels down to
a cent in silver ($4.75) and several in notes.

"You could mail a half doz. of cotton signs to
Kentville if you have some dry so you can mail
without putting paper between. I think they
would cost considerably less than by express. I
paid 25 cents on 1st and likely you did to the
(Windsor) Junction, making 50 cents. Better
write to Kentville and I guess you better send
some cotton signs there if you have some printed
even if you have to put paper in as that won't
add much to the mailing and they will come
quicker by mail.

Tell Laura (John's wife) I received her letter
alright. If you have any more mat photos you
could mail me some too. I promised Mr Turner
a set but don't get any more till I come except
what you have right now.(Probably a reference
to early flyers depicting available rug patterns).

"I am glad that Laura and the duffers (?) are
getting along nicely. I will likely write tonight if

63

I get time. It is cold today but I haven't experienced any cold on the road yet. I thought Laura had forgotten to write when I received two envelopes in Miss Fraser's writing. I thought both letters were from you and got the Post Master here to take another look but when I got them opened I was all right.

"Well I must stop, the day is going and I am getting nothing done-it is 10.30 now. With love to all, I remain

Affectionately Yours, J.E.G.

"(P.S.) Bank and P.O. want 5 percent off American money so I guess I won't send any till I try and get it worked off.

(The father and son letter shows both working closely together in a business relationship and there is no sign of a split. If a disagreement did exist between father and son it was more likely to have occurred in the 1894/1895 period when both had Patented art work in their own name.)

SHARING THE ARTISTRY OF PAST MAT MAKING

Unlikely probability of original hooked rugs surviving from the pre 1880 Mystery designs discovered in the Garrett pattern factory prompted replication of some of the rare designs in a Hands Across the Border project by Hooked Rug Museum supporters. Yvonne Hennigar, (above) of Chester Basin, co-ordinator for the Grandmother's Knee program created this amazing example. Others were to follow thanks to funds and materials sent from the United States.

Chapter 4

The Art That Was Tramped On!

"The next thing was a hook, and if Pa was a handy man about the house, he would make this hook from a large nail or perhaps from an old fork..." The New Glasgow Evening News

Those who were destined to become part of the Garrett dynasty were as intriguing individually as the American art form they dominated for almost a century.

They included Frank Garrett senior who moved his furniture business from Halifax to New Glasgow and ended up buying and patenting mysterious rug design stencils from his neighbor in business.

There was John E., Frank's son, who was the first known rug pattern designer in history to use pen and ink artwork smaller than an envelope from which he built a rug pattern empire.

Most artistic was Frank Garrett (Jr.), son of John, who was sent to New York to study art and design, ended up in a

class with Norman Rockwell. He was to become the world's first formally trained professional hooked rug designer.

There were John's other sons– Cecil and Arthur.

Cecil was business manager of the New Glasgow plant and Arthur and his wife Kit developed and operated the busy Garrett marketing center and factory in Boston and Malden, Mass.

There was Cameron, the son of Frank, (Jr.) who after all the others passed away, struggled to salvage what was left of the international business when ship loads of burlap, the company's key resource were being sent to the bottom of the North Atlantic by German U–Boats .

Additionally there was Claire, daughter of Cecil Garrett who was to marry a Sutherland and whose sense of heritage resulted in her saving vital documents and images of the once proud factory for future generations to enjoy.

We can catalogue some of the progress and the journey of the Garretts by following the trail of their consistently issued annual flyers, brochures and catalogues which emanated from both the Canadian and United States plants from 1894/95 through to 1974 when the last one appeared. Clippings and scraps of information from newspapers and magazine also help to fill in much of the amazing story that was born from an "art that was destined to be tramped on."

Like much of the world's rug hooking history-many components have disappeared, hopefully to emerge some future time. A rich heritage of Garrett history however is unfolding from the musty documents of their once bustling old factory which sold hooked rug patterns around the world.

Tracing a century of marketing along the trail of rug pat-

terns inscribed with the shadow of the 1892 John E. Garrett rug pattern factory is comparable to a roller coaster ride of the ups and downs of a stock exchange as it parallels historic moments and the ebbs and flows of society's development.

It has always been a puzzle for those scrutinizing available Garrett dynasty documentation as to why there appeared to be an ill-defined gap between the widely proclaimed Garrett promotions (in company brochures) that the Garrett manufacturing of rug patterns commenced in 1892 when there was no existing evidence of such activity until Frank (Sr.'s) acquisition of the Mystery Patterns in 1895.

Fragments of information help tell both the story and form the puzzle. The story finally takes form in the following explanation which our research extracted from a newspaper article of the day:

"Mr Garrett (John) commenced experimenting with rug patterns in his dwelling house in 1892 and for the first two or three years all patterns were made there."(That New Glasgow house still stands)." John Garrett at that time was associated with his father (Frank, Sr.) in the furniture business and continued until 1897, when he quit the furniture business to give all his time to Rug Patterns."

(As outlined in an earlier Chapter, there appears to have been at least one promotional flyer issued by John's father Frank prior to the 1897 date, possibly in 1894 when Frank obtained his first rug pattern design patents but more likely not until 1895 when he purchased outright the stencils of Kenneth Ferguson. That particular flyer contains Designs numbered 1 through 8, designs lettered ABCDF AND H,

and on the reverse, designs number 13 through 21, missing only number 16. It was undated)

Just why the design patent dates by Frank Garrett (1894 precede the actual purchase document between Frank and Kenneth Ferguson (date 1895) is difficult to comprehend.

The next oldest flyer is on newsprint. Badly damaged fragments indicate John Garrett was the publisher and it is noted that many of the Frank Garrett 1894 numbered patented designs are illustrated and offered for sale-although the name of Frank has been removed from the images.

The first John Garrett flyer bearing an identifiable date is the 1897/98 flyer. There are some distinct visual differences in the art work of the images depicted. Those patented by Frank Garrett are half tone reproductions and those by John Garrett appeared as line drawings in the rigid geometrical lines which earned him some later criticisms. A Victoria Jubilee rug was introduced in this flyer helping confirm the 1897 date. From the early numbers 1 to 21 on the patented listings of Frank's first flyer we now see the pattern numbers increasing to fifty three in John's flyer.

By December 1899, Frank Garrett senior had a closing out sale for his home furnishing business and concentrated his retirement years in manufacture of Manoleate soap. This was the last recorded mention of him after his surprise advertised entry into the rug pattern business and his purchase of the mysterious stencils from little known auctioneer and "somewhat of an artist", Kenneth Ferguson plus the patenting of rug designs in his own name in the 1894/95 period.

As the flyers progress into the early 1900's the pattern numbers and the variety of designs being offered increases

into the 100,200,300 and 400 series range. All of these appear under the name John E. Garrett. At this point John has refrained from appointing agents to represent his company. In his eighth year in business he is now beginning to innovate by creation of basic border designs for rug patterns into which can be inserted an emblem of choice such as Masons, Odd Fellows, Knights of Columbus etc.

By 1901 a fragment of a flyer illustrates the first attempt at publishing patterns displaying the use of color, quite innovative for the date. The example employed red, yellow and green tones but reproduced poorly in today's terms, partly because it was printed on newsprint. Numbers on the patterns had increased to 500 by this date.

The higher pattern numbers represented the start of new series and did not necessarily mean that the Garretts had 500 individual in actual production because in a 1902/03 flyer he boasts of "having a choice of nearly 100 designs."

It was at this time that we identify a broadening of the merchandise base with the first advertisement for Battenburg Lace designs. No indication is provided of their designer or the artist who achieved the delicate artwork. These patterns may have been an imported product line.

By 1904/05 John was segregating new designs from the older ones and for the first time we can clearly identify his own work which departs to a great degree from the early rigidity of the stencils to more flowing concepts of scrolls, leaves and the introduction of shamrock designs.

The following year (1906/07) there are more new designs and an announcement about a small expansion.

"Last year we commenced selling special hooks for work-

ing our rug patterns, these hooks were manufactured specially for us, and as we are bound to have a good article, we had to pay a high price and therefore could not sell them for less than 25 cents each. The large number sold at this price has warranted us in putting in special machinery for manufacturing these hooks on our own premises and we are now offering a better finished article at the reduced rate of 20 cents each."

Note- (The original upright lathe for cutting the metal rods to fashion into hooks of various sizes along with a home-made tumbler for polishing the metal hooks were recovered from the factory by the Hooked Rug Museum research team.)

Developing the U.S.A Market

Inconsistency in dating the promotional flyers makes it difficult to ascertain specific dates when John Garrett introduced new advances for his pattern factory's operation, however a flyer believed to be from the 1900 to 1914 period establishes several important developments. The pattern designs being offered ranged in series from 100 to 800 and offered a visual choice of some 65 illustrations.

For the first time we see in this brochure the address of 381 Dudley street in Boston, Mass., quite possibly the first Garrett flyer aimed at the U.S.A. market. Since all the endorsement letters quoted therein are of Canadian origin it can be assumed that it is near or at the early beginnings of marketing beyond Canada's borders.

In this flyer the Garrett reach also extended across the

Atlantic with the announcement that John Kendall of Mary-
port, Cumberland, England was to be their sales representa-
tive in the British Isles.

Then came the First World War and the early boom years
of sales and growth were to suffer a decline as priorities fo-
cused on the urgencies of the time. No record was discov-
ered of flyers being issued during the 1914/18 period - the
last being a single page leaflet dated 1913/14 which displayed
images of 18 rug pattern designs ranging in price from 20 to
60 cents each, depending on size.

"In the old days back in 1892, the first year's sales were
about 150 dozen patterns, the second year 350 dozen, third
year slightly over 500 dozen, and so on. From that time until
the War years (1914-1918) there was a steady growth. "

Just as would happen in the Second world war some 40
years later, sales dropped sharply during both wars as women
concentrated on replacing their men folk on the farms and
in industry while their husbands trooped overseas to battle
the enemy.

As the 1920's dawned John Garrett was busily experi-
menting with possible ways to increase the speed with which
rug patterns could be hooked. It was a frustrating effort but
John's persistence ultimately succeeded in producing an effi-
cient mechanized rug hook which he patented and produced
at the New Glasgow plant.

Initially marketed as the "Little Wonder" and later as
"The Speedy Hooker" (Article # SH-5) these prototypes
were first cousin to what would evolve later as the famous
Bluenose Rug Hooker. (Article # 7152) The major differ-
ence between units was that the "speedy" hooker was not

adjustable. The Bluenose Hooker could be set to create vary-ing size of loops permitting the user to vary the thickness of a rug. At one point there was a third variation, called a Bluenose Long Hooker which could make loops as much as three quarters of an inch high. (Article # 2518).

By the second world war the sale of the Bluenose rug hooks was to reach a million units. Components were then being manufactured at the U.S.A. plant in Malden and some were being assembled in New Glasgow.

During the 1923-24 period marketing flyers were issued in both French and English language editions, indicating ef-forts to build a broader based sales market in Quebec and New Brunswick and possibly parts of the northern United States. It was also a time to celebrate.

The Garrett factory at this point had been "Makers of Rug Patterns for the Women of Canada since 1892- over Thirty Years"

Product offerings expanded to include Sunset Soap Dyes and the more recognized Diamond Dyes. There was Bluenose Rug cement (used to seal the backs of punch hooked rugs which could become unraveled). There were iron clamps for rug or quilt frames, even special thumbtacks to hold the patterns in place. Bluenose Rug yarn was being strongly pro-moted as was special Bluenose Rug binding "used by the best rug makers today- 5 cents a yard."

To buy a pattern at this time usually cost 25 cents for an 18x32 inch design and up to $1.25 for a 45 by 81 inch size. If you preferred to create your own designs Hessian burlap in 36 inch wide size was offered at 42 cents per yard.

"Last year (1926) there were over 12,000 dozen patterns sold. The firm has used during the past three years nearly half a million yards of burlap in making "Bluenose" Rug Patterns or to be exact, 400,000 yards, over 250 miles of it."

The 1926 flyer, produced in both French and English, focused on "novelty rugs", oval and round patterns that *"are just as easy to make as the ordinary oblong rugs"*. A "nursery design" was introduced this year. The Boston branch was still listed at 381 Dudley street in this printing and the English agent continued to be John Kendall. Prices increased at this point due to rising burlap costs coupled with a change in postage rates which more than doubled from 12 to 25 cents a pound.

A Few More Words from John

A 1927 clipping from the Eastern Chronicle (New Glasgow) saved in an old file by Cecil "Dooley" Garrett notes that "Dad" (John Garrett) was invited by the Halifax Rotary club to give the same speech as he had given to the New Glasgow Rotarians"

Since we only have two original letters written by John (at a much earlier date) it is interesting to examine John's publicly spoken words in the context they were quoted by the newspaper reporter and which provides another perspective on how the company was viewed in the mid 1920's some 25 years after the business started:

"If there is one interesting industry in this community it is that of Garrett's mat making establishment. It is unique in

that it is the only one of its kind in existence. It is the cre-
ation of Mr Garrett's genius and its growth and success has
been due to his industry. When he came to state the output
of his factory he gave the Rotarians a shock, as it exceeded
everyone's expectations.

"His market is practically the world.

*"He supplies the English market, even sends
his wares to New Zealand and his goods are
on sale in the United States. He described the
process of making mat bottoms and stamping or
printing the designs upon it. He originates the
designs and if they appear to his taste he makes
stencils from the drawings and by a home-made
printing machine he transfers the patterns to the
mat bottoms.*

*He carries on an extensive mail order business in
Canada and has a mailing list of nearly 20,000.
He pays the New Glasgow post office about
$1,200 annually for parcel post carriage.*

*"In addition to the making of rug bottoms Mr
Garrett makes rug hooks, the ordinary old
fashioned kind, to the number of 25,000 annu-
ally and also a patented hand-hooking machine
which he invented and makes splendid work.*

*" Then he exhibited some wool rugs which were
made in his factory. They were complete and*

*really very beautiful in design and coloring. In
appearance they rivaled any of the much adver-
tised art rugs. There was not a Rotarian present
who did not wish one of those rugs for his home
and their examination evoked much praise.*

*" There is surely a great field for this work of
Mr Garrett and this was the more convincing
when he told of the prices being paid for hooked
mats throughout Nova Scotia.*

*Not long ago a New Glasgow lady was paid $50
for a mat and a lady at Sutherland's River was
offered and refused $75. for one.*

Mr Garrett told of some interesting incidents, one in par-
ticular where a mat on sale in Boston, was said to be over
one hundred years in one family and a large price was asked
for it. Mr. Garrett said it was his design and he has only been
in business about 25 years.

At the time of speaking John Garrett employed 3 men
and 18 women in the factory.

**This was the first public indication that the Gar-
rett factory had achieved full circle - from designing
patterns and printing them, to creating yarns and
dyeing them and finally to producing a completely
hooked rug for the retail market. The dream of John
had come of age.**

Some physical idea of the success was provided in another
article also published in the Eastern Chronicle during 1931

in which it was stated that the company's first year sales in Canada in 1892 were 100 dozen rug patterns and by the article's date in 1931 the sales volume had reached the 200,000 mark.

Significantly the factory was continuing to produce finished hooked mats as well as patterns using their own patterns and speeding up this aspect of the operation by using their own production of yarns and the popular Bluenose Rug Hooking machine to do so.

" Two thousand of these (rugs) have been put out, some of them as large as 7 feet by 9 feet. Local retail sales have shown a huge increase in the last few years, and in the summer months Garrett's is the mecca of the American tourists who visit this section of the province."

(From its launch in 1926 the Bluenose Hooker had reached a sales level of 30,000 by 1930. A New York firm alone had ordered seven hundred dozen by this time)

Returning to New Glasgow from his training at art school in New York, John's son Frank (Jr.) joins the company in the mid to late 1920's . (See Chapter 5)

Some forty years of pattern marketing had necessitated the introduction of new designs and by 1932 the popularity of the Bluenose rug series created by John's son Frank was apparent. It included a line of footstool or chair cover patterns about 18x18 inch sizes as well as a number of attractive floral designs from the same schooled artist .

The two most popular designs created by the younger

Frank in that period were Design No. B-100 depicting the famous schooner **"Bluenose "** which was in 29x41 inches and was also stamped on 36x47 inch burlap and Pattern 117, **"The Three Bears"** (28x45 inches in size) Both were illustrated in the catalogue.

How could anyone resist the promotional copy for the "Bluenose" rug- pattern-"Wouldn't you like to have a hooked rug as pictured above, showing her in all her glory, spray flying, all sails set, leaning to a stiff breeze, and clipping through the water with a bone in her teeth? You can fairly smell the salty tang of the ocean as she surges along to victory, to capture again the International Trophy."

The Garrett's Bluenose Pure Wool rug yarn was also receiving top billing, offering some 40 color tones (2 ounce skeins at 18 cents each) along with some pretty colorful advertising at the same time:

" If you have never made a rug with the Bluenose Hooker and Bluenose Rug Yarns you have yet to realize the supreme enjoyment to be had in creating yarn rugs of enduring beauty........for a beautifully blended rug....for a thick velvety nap...for a luxurious, soft rug...use Bluenose rug yarn!

Romanticism and art deco influences continued to emerge in rug designs of Frank Garrett junior's penmanship.

The **Tree of Life** made an appearance as did cartoonish designs reflective of the **Donald Duck** era along with images of dogs, notably the famous **"Scotty"** image and a stately collie.

Reflecting the historic trials and glories of the Garrett era were patterns depicting patriotism. Patterns displayed the Union Jack in various modes including one with a "There'll

Always be an England" war time motif. Others featured various Royalty images such as the Victorian Jubilee and designs commemorating the crowning, and visits to Canada by the Royals.

Many of the Garrett pattern sales were through departmental type stores. Amongst the factory record discoveries was an F.W. Woolworth store pattern book dated 1934 which displayed more than 60 rug patterns issued to that chain each September from 1932/33 through to 1949/40.

Some were unique, limited to Woolworths but many were variations on Garrett patterns, some the same or with minor alterations (the **"Three Bears** " for example were walking in the opposite direction to the original design.) Much of the original Woolworth art appears to have been lost but the printed images are still visible for reproduction once copyright has expired. This find adds to the number of identifiable Garrett patterns remaining in existence.

The largest catalogue sales of Garrett mat

foundations was produced in Canada by the now defunct Timothy Eaton Company. The Robert Simpson Eastern Company was also a prominent catalogue marketer and Dupuis Freres in Quebec was a major French language promoter. Independently the Garretts ran annual advertising campaigns in popular media of the day, particularly the Family Herald a weekly that reached most rural Canadian homes.

Search for a New Beginning

With the termination of the Second world war and return of many potential rug hookers from the military and war time

industries Cecil and Frank made a valiant attempt to jump-start the once famous factory that had been forced to close for most of the 40's. Still suffering the economic loss caused by Nazi U-boat torpedoes there was little money available for new initiatives or to relaunch marketing programs and restock depleted patterns. For the 1948/1949 season for example only a foolscap flyer could be issued, printed on one side with price charts on the reverse.

Pre-war pricing was generally maintained to try and stimulate a revival. Cameron Garrett in retrospect in 2007 looks back and reflects- **"We probably kept our price too low but we tried to bring the business back."**

It was a valiant try but the handwriting was on the wall. By the company's 60th anniversary in 1952 the John E. Garrett operations in both Canada and the U.S.A. could only muster a four page 5x7 folder promoting 22 of Frank Garrett (junior's) designs. It was a losing battle that would be compounded with the death of both Frank and Cecil- leaving Frank's son Cameron to carry on the ill-fated struggle for survival with many twists and turns for another 20 years.

Another brave attempt at revival was launched in the 1956/57 period with a professional looking pamphlet focusing on most of the best selling Garrett designs of the past half century while continuing to push sales of the Bluenose Bouquet Pure Wool Rug Yarn. It was extended a third year into 1958.

Again, in the period from 1960 through to 1965 the company's product line broadened to sweater designs with special Polar pattern books being offered and the Bluenose yarns continuing to be expanded to a use beyond rug hook-

ing. The brochure emphasized stamped needlepoint designs on canvas and in color, both singly and in kits. This promotion also included advertising for Rigby rag cutters which would permit cloth to be cut quickly into a wide variety of widths. A cougar hunt rug pattern featured the brochures front cover.

Time was running out however and by 1970 when another small brochure was printed and a final edition issued in 1974 it spelled the end of organized promotions for rug pattern sales.

An Art Like No Other Rises From the Dust

To understand the evolution of rug hooking from a utilitarian craft, through the stages of change from pioneer craft to a post-second world war folk art and ultimately to a late 1900's evolution as a fine art requires an understanding of where it came from and its probable destiny.

Unlike any other art form, the utilitarian hooked mat or rug is a subject that was originally meant as a floor covering, created deliberately to be used and abused and in most cases it was born of discards. **Simply stated it is probably the only artwork created in the world that was designed to be walked on.**

Being originally destined for destruction, this working role also erased vestiges of greatness that less utilitarian craft forms preserved. Apart from rare, seldom displayed treasures stored in the vaults of a few museums and galleries, it is sad to say that much of the better original rug art work has ended up in oblivion. Because of such neglect much of its early

heritage is dependent to a great degree today on replication of the original art that helped it thrive.

From those pioneer days when Grandad's long woolen underwear and the happily discarded uniforms of numerous winning and losing armies found their destiny by being torn into strips for reincarnation as both floor and bed coverings; rug hooking had become doubly unique as our New World's first, albeit elusive home-grown art form.

It's very purpose in being, in fact, has been its ultimate worst enemy.

Baskets and bins filled with waste fabrics can still be found in the cupboards and attics of many rug hookers to this day, reminiscent of a time when Grandma prudently tied stray pieces of string together and wound them into a ball for reuse another day.

Waste not - want not was the motto.

It was a craft that experienced constant change over almost two centuries as society discovered new forms of recreation and entertainment, were introduced to new materials, sought new outlets for skills and faced new challenges in the workplace.

The treasured memories of hand-hooked mats being created by family members clustered around a wooden frame, recycling old clothes, basking in the heat of a kitchen stove while winter winds vainly sought entry have mostly faded into history books; just like the radio skits of Edgar Bergen, Charlie McCarthy and Jack Benny which entertained those 30's artists..

The multiple skills of all needlework techniques, along with the hand-hooking of rugs have faced stiff competition

from an electronic age . Rug hooking has seemingly over-come that challenge – at first becoming a treasured folk-art during the mid to late 1900's and today, evolving as an amazing yet generally unheralded fine art form which some describe as painting with wool.

The redeeming feature of all this has been the discovery and preservation of the arts heritage. Behold the crafting of tin plate stencils, the carving of wooden blocks and the Gar-rett's magnificent art work, some of which through careful replication by qualified rug hookers is now being reincar-nated. An important legacy is being salvaged loop by loop so that future generations centuries can view and celebrate a unique American art that through neglect was almost lost.

John Garrett and his successors would be happy to know that traditional hooking is still the major form of rug making in North America with upwards of several million women and a few male addicts as enthusiastic participants.

Most today however pursue rug hooking as a hobby, a therapy and as a means of personal expression. Commercial rug patterns are still produced and older ones occasionally replicated. Today however originality has sparked a new era far removed from the original utilitarian purpose of mat making.

Fine Art Stage Has Arrived

Out of these traditions and with enormous credit to the insis-tence on high artistic standards by such dedicated individuals as the grand madam of rug making, the late great teacher Pearl McGown, is emerging a school of fine 21st century

artists in rug hooking that promises a whole new era for rug hooking as a wall hanging in tapestry form. In perspective it was most certainly the McGown era of teacher development in which fine art in rug hooking started to evolve and come of age.

As well as writing a number of significant books and tomes on the technical aspects of hand hooking of rugs Mrs McGown created the first known comprehensive Correspondence Course for rug hooking teachers.

(While apart from the purposes of this historic account, HRMNA researchers have recently discovered a series of 13 personal letters written by Mrs McGown which provides unique insight into the teaching methods she utilized in creating the nucleus of modern day hooked rug art and which it is hoped will be documented and analyzed in further publications through the eyes of those who practice her teachings to this day. But that is the subject of another story.)

In her letters to budding student teachers Mrs McGown patiently cultivated the true beginnings of fine art in a teaching mode. Still preserved on a scattering of aging pieces of yellowed mimeographed sheets those lessons and her personal critiques, sometimes interspersed with descriptive sketches illustrating her thoughts, are the foundation of her legacy of McGown Teacher's Workshops that have spread across the American continent.

She frowned on commercial rug patterns such as those which Frost and the Garretts produced because she felt they stifled creativity but she responded positively by demanding higher standards in technique and design whether commercial or original designs were being hooked.

Pearl McGown's Vision Realized

The historic craft has now achieved the vision of the late Pearl McGown who was to predict in her extensive writings on rug hooking that the craft and its evolvement as a folk-art form had a higher destiny (than being tramped on) which would one day be achieved as the skills and techniques advanced.

"Fine art" rug hookers now expert in fine shading and the art of subtle dying of materials continue to increase in both numbers and skills. They shun manufactured patterns in favor of blank burlap, monks cloth or linen foundations on which they can design their own personal creations.

Only a small percentage of the many addicts of rug hooking today actively belong to organized groups which are often led by part-time rug hooking teachers or commercial entrepreneurs.

Many informal groups have also developed from the initiative of a growing number of highly qualified rug hooking teachers, the seeds for which were planted by such leaders as the late Pearl McGown .

Many rug hookers today find mental and physical therapy as loop by loop they use their creative skills to fashion their own personal art, creating things of beauty from discards. Some also create rugs to alleviate boredom, many to augment widow's pensions.

In the "good old days" the skills of rug making, ranging from hooking to braiding, knitting, felting, and other variations were passed down from grandmother to mother, to

daughter. Today artistic innovation is encouraged as utilitarian need wanes.

Techniques as well as designs have varied over the passing years, varying from area to area, even culture to culture and sometimes even village by village -all factors of evolution that have added to the uniqueness, individuality and homespun creativity of the early craft.

The Winds of Change

Since the mid 1950's a new era of well trained teachers, new materials and dyes, a changing social perspective and broader opportunities have gradually wrought significant change in rug hooking both in its image as a utilitarian role, and its potential as an art form. Rug hooking has evolved in both fact and perception amongst both rug hookers and the general public -first from a utilitarian craft, then to a folk art and now-as an emerging original North American fine art form

In their persistent research into the mysteries of the long defunct John E. Garrett rug pattern factory the Museum research team realized that their momentous discovery of the original rug design art of past centuries is a significant and irreplaceable aspect of a broader awakening in a changing rug art world.

Significance of the Garrett art discovery and the Mystery patterns of an earlier era was accentuated by the fact that few if any of the early hooked rugs fashioned from those early designs still remained in existence.

Art curators are belatedly recognizing that with the original hooked creations long gone that now it is only the

surviving original rug pattern designs such as research has saved, plus a few early books and advertising sheets that now separate the early art from obscurity.

The few faded, ragged and sometimes well patched survivors of early rug hooking that have been salvaged are mostly a sorry reflection of their original self, many having been repeatedly walked over by the passing feet of several generations who usually considered them expendable.

Their aging burlap foundation base in many cases crumbles into the ashes of the past when handled. Most early hooked rugs, as one old timer succinctly explained, followed a path of use beginning with a few years of front parlor glory, an occasional respite at the bedside of a family member, often followed by a kitchen sojurn and then a brief good-bye as a back door mat. That last pause, used to clean the dirt off the pioneer farmer or fisherman's boots, was the prelude to being relegated to the backyard as a last-stand protective covering for the pile of winter firewood.

Replication Program-A Last Resort

With the recovery of more than 500 original pen and ink drawings and some 300 intricately hand-cut miniature stencils a new dimension has been added to rug hooking history.

The first major find of such original art, dating back to John Garrett's 1892 designs and possibly as much as another quarter to half a century to the amazing stencils that preceded him has created a challenge to historians as to how

such a heritage could best be displayed for public knowledge and enjoyment.

Thus was born from the discovery of the original art work of the designing Garretts a New Horizons for Senior's program (Government of Canada) titled "At Grandmother's Knee".

A unique idea, it evolved out of the face to face experience by the Museum's founding couple as their research carried them into the backwoods villages and seaside hamlets of historic Lunenburg County in western Nova Scotia where both early French and European influences remain evident.

Here, in these rural areas they discovered elderly folk- many widowed, living alone and wiling away long winter nights by hooking rag rugs in primitive styles just as their ancestors taught them more than half a century earlier.

Most had not been trained in modern-day rug hooking techniques, they did not belong to organized Guilds or rug hooking groups and many still hooked with hand-made rug hooks (a bent nail hammered into a hand-cut handle) using bars or frames suspended from chair backs on which they stretched pieces of burlap onto which they hooked rags cut in strips from recycled clothing. Chatting with them while basking in the long forgotten heat of a wood fire burning in a cast iron kitchen stove was a virtual step into the past.

Both a warm and spontaneous welcome was evident in these modest country homes just like the days of old, but there was sadness too as the elderly rug makers displayed accumulations of rugs which in better days they would have sold to passers-by to augment their slender incomes.

Now with advancing age, loss of a mate and fear of per-

sonal safety they no longer dared post their "Rugs for Sale" sign to encourage questionable visitors. Many had set aside their joy of rug hooking or continued to do so only to meet occasional requests of personal friends. They were isolated and lonely, reluctant to even allow the research team depart. Time was passing them by.

Opportunity came knocking with a 2006 Government of Canada New Horizons announcement encouraging senior citizens to apply for worthwhile community projects which would involve the elderly, stimulate their re-entry into community life in a rewarding manner , provide them with some recognition of their self-worth and open new doors of contact into their sheltered lives.

The need to replicate samples from the many hundreds of original pen and ink hooked rug designs made by John and Frank Garrett provided an incentive to seek financial support. Replicating such designs for future public enjoyment in as close to the original techniques as possible was the community challenge. The mainly widowed rug hookers who had learned rug craft from their ancestors, were themselves a treasure trove of talent. They knew and loved the historic designs and how to reproduce them in as close a manner as possible to the techniques used by their ancestors a century ago.

All the vital criteria of the New Horizon's program was in place with the exception of involvement with others in the community. Would each of these gentle folk from a generation past be willing to train a newcomer in the art of rug making? A quick survey indicated overwhelming willingness to pass along their ancestral skills to a new generation.

A funding program was born, designed to modestly support a co-ordinator who would be supplemented by volunteers. Contributions of pattern materials and an awards program were planned and two organized community groups offered structural support and sponsorship .An application for approval was submitted, approved and enacted.

This was the beginning of a new era in the art's struggle for preservation.

Significantly the advancement was not made without overcoming opposition. The year long Grandmother's Knee program tested the mettle of organizers who were challenged by a scattering of modern day rug hooking teachers who as "experts" questioned the quality of work which so-called untrained senior rug hookers might produce as well as their ability to train newcomers. The tenacity and enthusiasm of these heritage volunteers proved the doubters very wrong.

The organizing committee had wisely turned to a Nova Scotia Museum expert Robert Frame for advice, receiving his assurance that replication programs, based on use of ancestral skills was widely recognized by Museum authorities as the best way to ensure faithful rendition of an art that was now in danger of imminent loss.

Such ancestral knowledge and skills would ensure that the original form and techniques of early rug making were followed as faithfully as possible under contemporary conditions.

Even overcoming such objections did not open an easy road. One participant died in a fatal car accident just after completing her project, another was a victim of cancer and a number were hospitalized by age-related illness. Despite it

all the program was an enormous success in bringing back to life a total of 51 original Garrett rug designs salvaged from that historic old factory, for future generations to enjoy.

"At Grandmother's Knee" proceeded to enlist more than the targeted 50 senior rug hookers and 50 trainees-as intended, concluding the program with a major one-day exhibit before more than 550 guests, including local Member of Parliament Gerald Keddy who formally opened the display and commended the participants for their joint efforts to preserve a pioneer heritage .

The collection of some 110 hand hooked rugs was presented to the Hooked Rug Museum of North America for future exhibition. It was a movement which has continued to expand along with the heritage preservation it has fostered.

Art discovery of Unparalleled Importance

Effectively, the "Designing Garrett's" had met a need of home-makers in the late 1800's and 1900's , particularly those who did not have the desire or talent to arduously draw designs on blank burlap.

Coupled with John's invention of a highly efficient rug hooking device in the 1920's and the creation of new rug pattern designs by the talented artist Frank (Jr.) in the late 1920's and 30's this family of inventors and designers have made a major contribution to the history of rug hooking.

It comes as no surprise therefore that the "Designing Garretts" have earned the honor of being the first nominees to the Hooked Rug Museum's Hall of Fame.

At the outset the pioneers had used burnt charcoal sticks

to trace designs on animal feed bags, they hooked with yarns spun from the wool of their sheep and tore up worn out clothing in strips to be looped back into the mesh of a woven foundation for a multitude of uses . These included floor and bed "ruggs", chair and stair coverings, hit and miss mat designs for kitchens and intricate floral and scroll designs for front parlor and bedroom usage.

The Garrett's in turn catered to all those uses and others. They were prolific, but not always careful in controlling the numbering system they utilized to market their designs. To this day such provides some confusion over just which Garrett designer created particular images. Numerous duplications and modifications in pattern numbers have been identified.

While the earliest Garrett flyer shows a consistency in the sequence in which the designs were numbered- the emergence of parallel numbering systems at an early stage created both production and customer confusion.

As a result of this there is also evidence that the automatic fifty year copyright right protection of Frank Garrett (Jr.) designs and his descendants was extensively violated since the closure of the factory in the mid 1970's.

While hiding behind the excuse that ownership of his designs could not be clearly separated from those of his father John E. Garrett, various copyright infringements were obvious. In the case of Frank Garrett senior, (or Kenneth Ferguson) any copyright on "patented" designs would have expired by 1962. John's copyright protection on his personal design work expired at the end of 1987 but the prolific de-

signs of Frank Garrett junior did not expire and enter public domain until the end of 2008.

Ironically the early Garrett family was at one time challenged by Charlotte Stratton (who at one point held the copyright of the Edouard Sands Frost tin plate designs in the U.S.A.) She faulted the Garrett's for imitating some of them.

(★They were later cleared of this complaint).

In another unique situation Ralph Burnham of Ipswich, Mass. made a deliberate point to create replicas of early American designs of early hooked rugs which he was asked to repair as a rug restorer, an obvious copyright infringement. Conversely, as a result of his foresight it is ironic that he is now praised for having saved many early original American folk-art designs which otherwise would have been lost to posterity.

The dating of the bulk of Garrett designs is partially based on early flyers and brochures which sometimes carry confirming information about the date of design. Few of these remain in existence. In most instances only the early patterns that carry specific names can be established as being the work of a particular artist/designer.

In John's case his work seems to have been introduced in the period between the Frank Garrett (Sr.) patents and the specific work of his son Frank (Jr.). Early designs were at first simply advertised but after the turn of the century the "Scotia" pattern series was introduced under John's name. Most of the later series of "Bluenose" patterns represented the work of Frank Garrett (Jr.). Researchers still look for examples of John's early work which history tells us was

made on an individual basis during his itinerant work and as a favor to rug hooking customers who visited his father's furniture store in downtown New Glasgow.

In the final stages of the company very few original designs were issued, the last being the "Confederation Rug" created by Cameron Garrett with help from Miller Tibbetts. Cameron was alive and still active in heritage work in his hometown at this writing. His personal copyright still remains in force on all works he created.

In trying to sort out just which designer created what specific work our search first led us to compare situations where we could identify any connection between the mystery stencils, (so-called) and comparable materials in any of the advertising illustrating pen and ink drawings published under the names of Frank (Sr.) or John Garrett. We found some examples:

Number 7 Design. An original stencil showing a one quarter cutout scroll/leaf corner design on which is drawn in pencil the head of an antlered deer. (A stencil possibly cut by Ferguson, and the deer head, possibly added by John or Frank who may have redrafted the image for inclusion in a promotional publication. A complete reproduction of the same image as a toned wash image in mechanical form (printed) bearing the name Frank Garrett, New Glasgow, N.S is clearly Patented in 1894 and Marked No. 7

A very old flyer bearing the name and address of John E. Garrett, New Glasgow and printed by John Lovell and Son. 234 St Nicholas St., Montreal in which the same # 7 is offered for sale does not have Frank's identity displayed. The cutout stencil scroll and the pencil drawing could have been

done by two distinct artists. It was then "patented" by Frank and marketed without credit by John Garrett. The date of 1894 as shown is a year later than the agreement between Frank Garrett and Kenneth Ferguson.

Number 12 Design. In this instance we again have in our possession a mechanical impression of a completed rug design by Frank Garrett (senior) dated 1894 and marked as follows: Pat. 1894, No.12

We also have the early John Garrett flyer as described previously but the image shown for Number 12 Design while it contains obvious similarities is a distinct modification of the original Frank Garrett patented image. The original Frank Garrett image appears to have been modified by John for use in his flyer. John's repro utilizes the same scroll and leaf concept typical of the unidentified stencil designer but in a different layout and he has totally eliminated the central floral design leaving the centre of the rug plain. Indications are that both # 7 and 12 were redrawn by Frank or John, possibly both.

Number 2 Design. Here we have a sketch of a reclining dog posed in a stencilled frame design of scrolls, lines and loops which has been later redrawn as a pen and ink image with added texture lines in the photo copy which are absent from the printed image. Further study indicates a redrafting similar to # 7 where the deer head was patented in Frank Garrett's name. One conclusion is that both images, had been modified, possibly to improve reproduction for advertising purposes.

Number 20 Design We have on record Frank Garrett's designated Number 20 design, a scroll/ floral combination

also clearly bearing his name and marked Pat. 1894 in a half tone printed form on cardboard.

When we compared this Frank # 20 to John Garrett's Number 20 as published in the flyer we found it totally different. The John Garrett rendition showed a startled horse in full flight surrounded by a classic sculptured border.

Conclusion- John was apparently mixing and matching his own designs with those from Frank Garrett's collection (where ever such may have emanated). This turned out to be one of many instances of numbering confusion identified earlier.

Number 3 Design We have the faded but a mechanically reproduced half/tone image of a floral basket surrounded by a typical stencil-type scroll system. It is also patented 1894 but Frank's name is missing, possibly cut-off the image. In the flyer we have a conflicting Number 3 depicted as a Maple Leaf border with blank center. This is evidence of two distinct early images bearing the same number.

There are other examples of numerical duplication and conflicts between Frank Garrett's designated patents of his art or his technique of reproduction and both the original group of mystery stencils as well as marketing usage by John of what is credited as Frank's design work .

The undated very fragile John Garrett newsprint flyer with which the comparison study was made is estimated to date back to the 1897/1898 period. It may have been John's very first marketing promotion.

A further flyer, also bearing John's credit line as manufacturer of the Garrett patterns is on more stable paper and smaller in size but it includes a Victoria Jubilee hooked rug

design carrying the date 1897 in large figures, leaving little doubt of its issue period. Interestingly it included 12 rug pattern designs clearly naming Frank Garrett as the owner of such and indicating the patent date of 1894.

Our next example focuses on a fragment of a flyer of similar nature to the foregoing (possibly even part of the same one, which bears a rubber stamp designation F. Perkins of Charlottetown, P.E.I. as the sales agent, It depicts a Number 26 design of another prancing horse with a horse-shoe border along with four more Frank Garrett designs and a number of line drawings, most likely by John himself.

Conclusion- No doubt remains that father and son were working co-operatively to market rug designs at this point in time. Questions however still exist as to whether these were reproductions of the original stencils acquired by Frank from Kenneth Ferguson under the 1895 contract or if indeed Frank actually created the designs bearing his name or simply laid claim to them.

The 1800's research terminates with the clearly identifiable date of 1900 on a John Garrett flyer continuing to promote a rug design offering the insertion of emblems for various fraternities such as Masons, Odd Fellows, Knights of Columbus, and Foresters -a design appearing to have its origins in the Ferguson Mystery stencils.

(An original hand-colored survivor of this design was recovered for the Museum's collections by Edward MacArthur at auction in 2007 –it bears the date 1895 and John Garrett's patent reference. This indicates how early in time that hand coloring of rug patterns was taking place.) Also marketed are rug hooks (for the second year) at a price of 20 cents each.

Designed to encourage new rug hookers to get involved this flyer promotes mail order purchasing and even provides basic instructions on how to hook rugs and the economic use of recycled clothing as the basic materials. The printing of the flyer was handled by the same John Lovell and Son company in Montreal, making it apparent that the future Garrett "printery" had not at this stage been established.

The Little Hooker That Made Good

While mechanical hooking devices are frowned on by contemporary rug hookers those who made a living hooking rugs prized the Bluenose Hooker. John Garrett and his son Arthur developed and introduced a number of variations ranging from "The Little Wonder", to "Bluenose", "Speedy" and a high loop variety-. Worldwide sales reached an estimated one million hookers. For the 1920 to mid 1940's period, it was an amazing achievement. His little factory also produced more conventional hooks that sold for a quarter each. Examples of his competition are depicted in Rachel Hardy's collection of early hooks (bottom image)

Hand Carved Rug Pattern Unearthed

This unique solid wood block rug hooking pattern found in the Garrett factory was a surprise to researchers. Both Frank Garrett Sr. and his son John E. were talented wood work-ers.It was probably made by one or both of them No one suspected that such a rarity existed, until three of these in different designs were discovered. . The carved wood block designs (probably pre 1892) may have been experimental and too cumbersome for production purposes.

Chapter 5
A Major U.S.A. Market Unfolds

"Everything was now ready to commence hooking and so, on the long winter nights she would work industriously by the light of the tallow candles, often assisted by the neighbors who would drop in for the evening. These were the happiest hour - a time for social chat as well as working, to the accompaniment of the crackle of the open fire and the hum of the tea kettle..." **New Glasgow Evening News**

A very substantial portion of the Garrett rug pattern business was conducted in the United States and was organized by John himself during the early start-up period and later operated by his eldest son Arthur Garrett (when he came of age) along with his wife Katherine (better known as Kit). Arthur was the first son of John E. Garrett

Born in New Glasgow in 1888 after his grandfather Frank (Sr.) had relocated his furniture business from Halifax, Nova Scotia to the shire town, Arthur moved, as a young man to New England where he married twice. His second wife

Katherine (Worman) Garrett was said to have operated the U.S.A. end of the factory operations after Arthur's death in 1954. Being mechanically minded , Arthur would have been an important asset to his father during the patent development period of the Bluenose hookers.

The date that Arthur migrated to the United States from Canada is unknown, but during that period in the early 1900's he would have joined an influx of many young Maritimers who sought employment in New England's bustling industrial areas. Many of them like Arthur, never returned to Canada, having married and raised their families while there.

There is proof that John Garrett's business enterprise had already been extended to the Boston area shortly after the beginning of the 20th century. Since Arthur would have been quite young at the time, this outlet would probably have been operated by some other unidentified member of the Garrett family who may have still resided in the United States or alternatively by a local entrepreneur who was acting as an agent.

One of our earliest flyers to identify a United States marketing promotion by John Garrett is not a rug hooking pattern advertisement but an offering of Patterns illustrated with very delicate and exacting artwork **"for Battenburg and Point Lace Work"**. They were listed as being "manufactured in New Glasgow" and included Cambric patterns for centerpieces, lace doilies, table covers, and tray cloths plus braid, and edging. Few are aware that lace was once made in New Glasgow.

The flyer did not totally neglect rug pattern promotion however. It was addressed :

> Dear Madam: "Have you any friends in the States who are interested in hooking rugs? We have a branch office in Boston. Our address there is John E. Garrett, 1058 Tremont St. If you have any friends in the States who make hooked rugs or are interested in them you will do your friends there a favor as well as us by sending their address to us or sending them our Boston address so we can send them a sheet showing the rug patterns we make in the States."

This particular flyer was probably issued in the 1900-1910 period (based on its vintage and style). Obviously John Garrett was gearing up around this period to launch a thrust into the U.S.A. market place.

While the first significant "company store" was located in Boson, this was primarily a sales outlet and a marketing center for catalogue generated business. It is significant (but otherwise unconfirmed) in that it indicates Garrett rug patterns were being manufactured in the United States at the time the flyer was issued.

Again the New Glasgow Evening News provides a hint in a 1934 article: " For some years the (Garrett) firm has maintained a branch in Roxbury, Mass, shipping goods up from here. Owing to the high duty paid to Uncle Sam it was decided to manufacture in the U.S.A. In 1925 a plant was

purchased in Malden, Mass., where Mr Arthur Garrett is now in charge."

We have a dated 1932-33 single-page flyer which was designated as a "Price List to the Trade" indicating whole-sale pricing, and addressed 381 Dudley street, Boston which offered rug patterns by the dozen (example- a 28x45 inch burlap pattern @ $5.00 per dozen). This was probably an outlet store for the Malden factory. The research team also has a USA made Garrett rug pattern in their collection.

Another newspaper article (origin unknown) but hand-dated Nov 19, 1936 validates our previous data on Malden:

"Until ten years ago all patterns were manufactured in New Glasgow and shipped to the United States. Due to the great increase in trade across the border and to save duty and shipping, a branch factory was started in Malden, Mass."

This would establish a date around 1925-1926 for rug pattern manufacturing by the Garretts in the United States. We have an illustration of the Garrett factory building in Malden which shows several vintage automobiles parked in front, both of the late 20's or early 30's period.

World War I was over and despite the Great Depression that followed, rug hooking thrived in both the twenties and thirties. It was around this period as well that the New Glasgow plant was actually reproducing designs for such in-dependent firms as Bucilla and Fleisher and others in the United States.

We have found artwork used for this purpose and also recovered imprinted perforated stencils bearing the United States company's name. We also found brochures which fo-cused on the John E. Garrett name and the U.S.A. Malden,

Mass. address but notably played down the national origin of the company by inserting in much smaller type "Canadian factory at New Glasgow, N.S. Canada" instead of highlighting it.

Next we became aware of a larger format catalogue which appeared in the U.S.A. market place this time specifically stamped "printed in the U.S.A." and bearing only the John E. Garrett Malden address.

A partial newspaper clipping probably written about the late 1920's or early 1930's based on statistics included in the text- gives some idea of the overall volume of sales being recorded: ***"....before the depression as many as 120,000 patterns were sold in one year."***

"The business up to ten years ago (around 1920) consisted in the manufacture of burlap patterns and the old fashioned rug hook. For a number of years Mr Garrett (John) had been experimenting on a semi-automatic hooker with a view to making the hooking of rugs easier,

" After years of experimenting and the burning of midnight oil and not without many disappointments, Mr Garrett at last perfected what is known as the "Bluenose Rug Hooker". This little device has been a great success and is now patented in Scotland, Britain, United States and Canada. It is manufactured in the Malden factory. One New York firm alone, with branches in Chicago and San Francisco has bought over 250,000 Bluenose Hookers."

Another "Bluenose Hooked Rugs" catalogue (printed in the United States) in this same period is the first example of how the Garretts adeptly moved to multiply rug pattern sales

by designing and linking similar patterns together to create sets.

These were undoubtedly creations by Frank Garrett (Jr.) and employed flowing lines using a similar compatible design in four different rugs including an oval, rectangle, circular and half circle design.

In the same catalogue Pattern No. 575 depicted a 21x30 inch design which*: " can be worked singly and used as a small rug, but it is designed for those who wish to make an extra large rug. Almost any desired size of rug can be made by working a number of small rugs and sewing them together after they are hooked."*

Subtle marketing of an idea designed to increase individual pattern sales to the consumer who was always on the lookout for new ideas to upstage their friends.

Hooking as an "ART"

By 1936 a brochure in the Garrett name, again published with only the Malden address, depicted a fireplace scene with two home-made rugs, one on the floor and for the first time in a promotional illustration one was shown hanging on the wall over the fireplace.

The Garretts were obviously engaged in planting the idea of using hooked rugs as wall hangings as they saw the craft moving from utilitarian roles to a folk-art. John had inherited the marketing sense of his father and maintained a strong finger on the pulse of rug hooking both in leading the trends and sensing the changes. The illustration in the wall hanging was of a moose gazing out over a forest fringed lake.

The same image had been widely circulated as a demonstration piece featuring the Bluenose speed hooker.

It was again Frank Garrett designs that were illustrated and as the brochure emphasized they were "quite charming". Customer praises came from everywhere. Messages bore community names from Fairburg, Nebraska to Nanaimo, British Columbia, from, Ohio, to Elk River, Minn.

The Bluenose Hooker devised in Nova Scotia and produced in Malden had become an American icon. By this date over 260,000 were already in rug hookers hands.

Validating this, we rescued from the New Glasgow plant a heavily stained and faded letterhead from the "Boston Chicle Co. of 53-55 Bryant St in Malden, Mass. which marketed " Chewing Gum of Every Description" and specifically mentioned a few brand names of interest to this day- A.I. Pepsin, Chu-Li-Ket, (note-today's Chiclets), Slot Machine Gum, Carleton's and Spruce Pepsin (from the Carleton Labratory, Established 1848). (This same factory building had earlier been acquired by John Garrett from the Robbins Chewing Gum company).

The letterhead was obviously recycled- used as scrap-paper by Arthur Garrett to send a note to the New Glasgow factory accompanying a group of rug designs for reproduction from the Bucilla and Fleisher company. The typed note to the Nova Scotia factory displayed a hand-written listing of pattern numbers and sizes and the typed admonition:

"Be sure and tell the Customs that these tissues are not staying in the country at all. They are just sent to be perforated and are going right out again. In fact if it were hired help that did the perforating they would be actually giv-

ing employment in Canada rather than taking it from them which imported goods are supposed to do."

It was obviously a cost saving feature to use equipment in the New Glasgow factory to perforate the stencils for bulk printing in the United States factory, rather than engage in the costly shipping costs involved in producing the finished patterns in Canada and then being subject to additional custom's duties. Whether the Garrett factory in Malden printed rug pattern designs for other United States companies is not known.

The Garrett's also adeptly worked advertising for their Bluenose Rug Hooker into many of their competitor's catalogues. One of the major production roles at the Malden branch was in the "stamping "of many of the metal components of the Bluenose Hooker as well as the bulk assembly of units of this popular hook to meet the massive United States demand for John's unique invention.

In this instance there was some cross-border transfer of components. Metal parts would be shipped to New Glasgow for Canadian assembly and distribution and Canadian made components such as the wooden handles would be sent in return to the Malden factory.

Of the one million Bluenose hookers eventually manufactured and sold, one distribution company in New York alone was reported to have sold 250,000 units.

As late as 1940–41 research has confirmed that John E. Garrett had published a United States rug pattern and supply catalogue for consumers which still showed the street address of 381 Dudley Street, Boston, Mass. This sixteen page promotion with a three color cover depicted a woman using

a Bluenose Hooker on an upright frame, being assisted by a youngster holding balls of yarn.

The contents are predictable-the inside front cover highlighting 16 unique footstool or chair covers (pattern numbers ranging from numbers 925 to 957). There was a new water wheel and mill pond scene (pattern M2) and an explanation about how to create a "runner" by repeating certain patterns offered in the book (#'s 412,4134,820 and 784) which was another promotion designed to increase sales volume. There was a mix of geometrics from the past and more animated dog, cat and scenic views from Frank Garrett's talented pen.

"Perfection dyes "trade mark registered in the United States" was being marketed along with both the Bluenose Rug Hooker at $1.00 and the Speedy Hooker at 40 cents, both probably produced in the States. Bluenose Rug Yarn (manufactured at the New Glasgow factory) was also being offered at 30 cents a skein.

Some idea of how significant the United States rug pattern market had become to the New Glasgow parent firm was recounted in a newspaper article published in the Malden (Mass.) Evening News and later republished in a Halifax or New Glasgow paper.

JOHN E. GARRETT BUYS PROPERTY IN MALDEN, MASS.

"The following from the Malden,(Mass.) Evening News of the 20th instant will be read with marked pleasure here:-

"John E. Garrett of New Glasgow, N.S. who bought the Robbins Gum factory, 87 Bryant St., several months ago and founded a new industry here in hooked rugs craft in supplying patterns all over New England has found his business growing so rapidly that he has been obliged to seek additional quarters. This week he bought the two storey building at 105 Bryant St., not far from his present plant and will greatly enlarge his operations.

"The building, lately occupied by the Malden bedding company, which was built by the late Representative Charles L. Davenport, was once occupied by a large grocery store on the first floor, carried on by the late Harry M. Hardwick. The second floor was devoted to a Ward seven political club.

"The building is 40x47 feet and there is a steel shed in the rear 20x50. Mr Garrett who is a Pictou County, N.S. man is the pioneer hooked rug manufacturer of the Maritime provinces and has built up a great business. He is a member of the New Glasgow Rotary Club and often lunches with the Malden Rotarians."

Consisting of about 2,000 square feet on each floor the three level Garrett Pattern factory was an impressive frame structure, bearing the BLUENOSE emblem on one end and

the John E. Garrett name on the other. Indications are it had nine or ten permanent employees.

By Jan 7, 1938 the Malden Mass. "News" reported a break-in and attempted theft at this same plant:

MERRITT SAVES LOOT IN BRYANT STREET PLANT

"The timely arrival of James Merritt, custodian of the John E. Garrett hooked rug making plant at 85-105 Bryant St. at the plant at 3.45 p.m. yesterday saved the place from being cleaned out and thwarted a break which apparently had been made by one man. As Merritt arrived he heard a noise on the second floor and investigated. He saw a man run out the rear door. It developed that entrance had been gained by forcing a second floor door, off the fire escape. A bunch of overalls and sweaters, owned by employees were in a pile for removal. "

A somewhat different looking brochure also caught our U.S.A. researcher's attention. The "Bluenose Hooked Rugs" designation was unmistakable - A flip-through showed the usual array of Garrett rug designs. However on the reverse was a new marketer-the Colonial Yarn House of 1231 Cherry Street in Philadelphia, Pa. The Garrett operation was growing bigger and continually reaching out to new horizons. There were many old Garrett pattern catalogues we discovered which carried the identity stamps of Garrett agents , ranging all the way from nearby Prince Edward Island to

far distant British Columbia in Canada, One of the more interesting agents identified was one Mrs Frank W. Evans of 215 Manhattan Avenue, New York City, N.Y. Could this "agent" have been the individual who provided Frank Garrett (Junior) with accommodations and support when as a young man he took art lessons with Norman Rockwell in that same city? She was still selling Garrett patterns and supplies as late as 1941.

A "Bluenose Patterns for Hooked Rugs" brochure for the 1959-60 John E. Garrett Ltd. factory was apparently a joint use publication for both the New Glasgow plant and the U.S.A. operations at 105 Bryant Street in Malden which was still operating at that point. By the year 1954, Arthur had passed away after building with the help of his wife Katherine a major rug pattern empire in the United States. He was 66 years of age. His wife Kit continued the United States business until it was terminated in 1974-75. Claire (Garrett) Sutherland advised us that "Cammie (Cameron Garrett) and I attended (Arthur's) funeral with Aunt Kate and Uncle Don of Truro in June 1954- we drove there." (to Malden, Mass.)

LAST FACTORY OWNER

Edward "Eddy" MacArthur (above) acquired the old Garrett factory and its contents from Cameron Garrett when it was decided to terminate rug pattern making in the mid 1970's. He continues to operate the premises as Garrett's By The Bridge Antiques . We are indebted to him for his knowledge of rug hooking heritage and the factory operation itself . The bottom image is just as we found this rug hook manufacturing area,

1351

Surprised at Discoveries

When Museum researchers discovered more than 500 pieces of pen and ink art work made by his father and grandfather, Cameron Garrett, the last surviving Garrett manager of the 1892 rug pattern factory was delighted (above) as he celebrates with Museum Founding Director Suzanne Conrod. He also found samples of Frank's art in his attic (Bottom image) and added them to the collection. When told about a further amazing find in the factory of some 350 hand cut paper stencils he expressed amazement. He had not known they existed.

Strong United States Presence

The Garrett factory operation in the United States was substantial, It included manufacture of rug patterns as well as components for various types of the Bluenose punch hook.. The Garretts operated an early outlet in Boston, later acquired two buildings in Malden, Mass, (above) to cope with increasing sales volume.. They had an agent in New York and were represented by various wool and pattern making companies including Bucilla and Fleisher as well as community outlets in grocery and small wares shops. Arthur Garrett, John's son and his wife Katherine directed the New England operations.

Chapter 6
The Rockwell Connection

Most talented of all the artists amongst the designing Garrett quartet was undoubtedly Frank Garrett (Jr.) the son of John E. Garrett who was dispatched by his father to New York to take formal art studies. The timing of this assignment turned out to be opportune. Young Frank had the unexpected privilege of becoming a classmate of another great developing art figure of the period, folk-artist to be- Norman Rockwell.

It may in fact not be coincidental that images of various hooked rugs are depicted on the floor of many of the folk art renditions painted or drawn by Rockwell. The young artist from New Glasgow, Nova Scotia may have influenced his choice. Most certainly they shared a love for hooked rugs.

The Ruggery of Glen Cove, New York , makes note of the fact that Norman Rockwell purchased two abstract floral designs in the late 1950's or early 1960's. A replica measuring 8x9 feet was remade for the Norman Rockwell Museum in Stockbridge, Mass.

In sending Frank to art school John E. may have recognized his personal lack of professional training but having devoted his entire life to hooked rug design he was also smart enough to know that refreshing and innovative patterns were necessary to retain and expand his aging company's clientele.

John Garrett's early designs had been marketed for a quarter century and after his New York training Frank (Jr.) faced the challenge on his return to New Glasgow that a new and more contemporary look was required.

Youthful Frank was ultimately to provide the company with many exciting and popular new design concepts which would continue to build the rug pattern empire for another quarter of a century.

John Garrett may have been stung by some criticisms of the early rug patterns he was marketing. Critics had publicly frowned on the rigidity of some of his designs. Other negative criticism had came from purists who complained that commercial rug pattern designers in general were undermining the originality of rug designs and stifling the creative initiatives of rug hookers by the marketing of ready made designs. Little is known of John's personal drawing skills or whether he had ever received any formal education in the art field.

(The critics of mass produced commercial rug patterns probably did not comprehend (as we do in retrospect) that the early artists in this field were quite limited by the lack of flexibility that technical limitations enforced on the pattern manufacturing process in that period.)

Designs, hammered out of inflexible metal, carved from hard wood or hand cut from paper left the artist a very limited range for creative expression. Virtually all of the Mystery pattern stencils as well as many of the Edouard Sands Frost tin plates reflect the stiff lines and limited scrolls dictated by the stenciling materials used.

John E. Garrett may well have been unfairly criticized in this regard- since his designs in pen and ink did offer a wider range of creative content than earlier techniques. If as is suspected neither John nor his father Frank (senior) were the designer of those very early Mystery Patterns, they have only themselves to blame for being recipients of such criticism if they indeed adapted some of these stencil designs for their own marketing purposes.

Taking credit for specific work not of one's own creation, risks accepting the blame for inherent flaws and can run afoul of such situations as when the 1894 "patent" designations by Frank (Sr.) in which he publicly advertised 21 rug designs were later published under John E.'s banner. The issue of who actually designed which patterns not only continues to generate confusion but has continually raised the question about whether it was John's designs under attack, or those of the designer of the Mystery patterns.

Complicating the identification of the actual art work of John and Frank (senior) Garrett is the intrusion of the stencil work of the unknown Mystery pattern designer whose work may or may not be directly attributable (from an art design viewpoint) to the Garretts. The only direct link between those stencil patterns and the Garretts is the contract with auctioneer Kenneth Ferguson and its does not specifically

identify If the stencils acquired by Frank Garrett senior from Kenneth Ferguson are in fact one and the same as the stencils we found in the abandoned factory basement . It does however appear that the Garrett's decided the only way they could market the Mystery rug stencils in pattern form would be to convert them to half tone images that could be reproduced for advertising purposes. The stencils alone, as cutouts could never be visually marketed unless enhancing artwork had not been produced. This may be the best explanation of the riddle we have been chasing.

Conversely, if this assumption is accurate, it means the search for the unknown stencil designer still remains to be solved and the Mystery Pattern designation which we have applied to their identity continues to remain valid.

We have visual proof that a number of the original stencils were actually modified and insets added during the process of converting them into half-tone replications so they could be better pictured in the advertising flyers we have examined. Since some were published under both Frank and John's name in Garrett flyers they do become suspect.

Resolution of this historic dilemma may ultimately depend on forensic research which may be able to date the age of the paper from which the stencils were cut. Even such a 21st century analysis however would not be able to identify if it was indeed Kenneth Ferguson or someone else who did create those amazing stencils. Facing such facts, doubts remain that this enigma will ever be fully resolved.

Such confusion does not reign however with the much later artistry of Frank Garrett (Jr.) as here we are able to see an identifiable visual difference between the pen and ink art

work designs reasonably attributed to John Garrett and that of his son.

While neither signed their names to their original pen and ink art work the studied eye can separate the more rigid creations of John E. from the contemporary work of Frank. The latter's art work is more sophisticated creatively, with few flaws and the images themselves, abetted by less aging, stand out from the older renditions. Another and simpler path to artistic accreditation lies in the fact that the little known Scotian series of Garrett designs are the later work of John while the Bluenose series appears to be all or mostly have been created by Frank (Junior).

Interestingly, while there was a large collection of Scotian series patterns this name was not prominently advertised and even some so-called experts to this day erroneously label some of them as Bluenose designs.

A further visual separation of the work of the elder Frank Garrett and son John E. from that of Frank junior can generally be identified in the annual brochures and flyers published by the company on a consistent basis from the late 1800's to 1974 when the last catalogues appears to have been published. (It is important to note because of contrary claims that the identifiable art of John E. has long since lost its copyright privileges (50 years after the artist's death in Canada). In the case of Frank (Jr.) his death was recorded in 1958 and based on the accuracy of that information the copyright on his artwork would have remained in existence until the end of 2008.)

As a courtesy to the Garrett family who inherited copyright on the early designs, our publication of images from

their ancestor's work has been delayed by this research team until 2010.

While in the past it has been difficult (if not impossible) to accurately identify the art of one Garrett artist from another. discovery of the original art work has eliminated most of the doubt about just where copyright still exists, such as the more recent limited work of Cameron Garrett.

Rockwell and Garrett Share An Era

The late 1800's was an era of social change shared by both the Rockwell and Garrett families. Frank Garrett (Jr.) was born in 1892, Norman Rockwell was two years younger, born in 1894. It was a time that America was coming of age and had great pride in its roots and heritage.

Norman Rockwell's notable art largely reflected that heritage. In contrast, Frank's rug pattern designs were a step ahead of the more conservative rug design work of his forefathers. He was probably the first commercial rug design artist to have received professional art training- and it showed. He was a distinct part of the evolution that rug art was experiencing.

History recounts that Norman Rockwell left high school to study art at the National Academy of Design in New York at the age of 16. This would have been circa 1910. Frank Garrett would have been two years older (18) so it is likely that he would have been in New York as an art student somewhere between 1910 and 1914.

We do know that Rockwell transferred at an early point in his art studies to the prestigious Art Student's League. It

is believed that Frank Garrett could have been a student at the New York School of Art or more likely at the National Academy of Design when the two became classmates.

Cameron Garrett, Frank's son, believes that his father lived with some Garrett relative while studying art in New York. There are also other indications that the Garrett's had some form of outlet or agent (See Mrs Evans, Chapter 4) in New York around this time, Possibly too it was Arthur Garrett who became manager of the Boston and Malden branches of the Garrett company and was Frank's brother. He could have provided Frank a place to reside while he advanced his education.

We are unaware of any communication that may have transpired between Frank and Norman Rockwell after their studies and parallel careers separated them, but we have identified a link which may be more than coincidental.

In the plethora of magnificent folk art images that Norman Rockwell left as his heritage we have discovered that hooked rugs were on some occasions included in Rockwell's artistry. Whether such images were influenced by Frank Garretts' design work while in arts class with Rockwell will probably never be known. Since hooked rugs were part of the early American scene, it is logical that some would appear in art depicting that period.

At the age of 22 Rockwell had completed his first cover illustration for the Saturday Evening Post. Over the next 47 years he is reported to have created an astounding 321 Post covers, plus numerous other great works. It is amongst this lifetime of work we identify images which included rug patterns.

One of the most notable examples is a nostalgic scene of an elderly couple titled "Keeping Company" which has been approved by the Rockwell Family Trust and certified as a true classic by the Rockwell Society of America. This image can be found on the seventh edition of an Edwin M. Knowles (limited plate series) issued by the Bradford Exchange.

The back plate inscription quotes Thomas Rockwell: "Sharing a quiet moment with someone dear to your heart-A golden moment to be cherished."

Other examples of rugs or mats in Rockwell illustrations have been identified, both by ourselves and by Arthur Young in "America Gets Hooked"-History of a Folk Art"-. They appeared on Saturday Evening Post covers at least seven times.

The Post's Oct. 22, 1927 cover depicted a hooked rug in a Rockwell painting- "Tea Time", while on March 4,1929- an illustration named "Twins" and on March 29 of the same year the famous "Doctor and the Doll" painting both included hooked rugs in the images. Other rug art inclusions can be found in "The Baby Sitter", "The Game" and the "Armchair General".

The list goes on- there were rugs in Rockwell paintings such as " Choose Me" (Saturday Evening Post, May 4, 1929). There were similarities that have been pinpointed in some Rockwell art to Garrett heritage rug patterns- such as Pattern 413 of the Garrett U.S.A. rug pattern catalogue (circa 1940).

Having the great Rockwell recognize that rug hooking art was worthy of preserving in his extremely popular folk

art format, is an association that rug hooking in general must view with delight.

A significant artist in his own right

While enjoying a parallel artistic career in the era of Norman Rockwell, Frank Garrett (Jr.) was an outstanding artist in his own right, regardless of the fact that he made his living primarily on the basis of a commercial art form.

A major oil painting, depicting an unknown elderly model who posed for one of his New York art classes, is a striking example of Frank's amazing artistic ability. This painting hangs today (2009) in his son Cameron's home in New Glasgow. Frank's artistic talents were re-directed from portraiture to commercial genre at an early point in his career. He did from time to time dabble with drawings of such greats as Winston Churchill.

A former Mayor of New Glasgow, the late N.W. Mason has been captured in one of his sketches, possibly drawn during the period that Frank served on that community's town council. He served as a councillor for two years representing Ward 2 and was a close friend of Mayor Mason.

First employed in the Garrett pattern factory at 13, he worked after school doing odd jobs around the plant and making rug hooks-tasks which would later be inherited by his son to be, Cameron.

In today's home of that same son, a number of Frank's beautiful pencil sketches, (mostly rural scenes) and also including one of his pipe-smoking father John Garrett, are framed and displayed for family enjoyment.

Primarily though, Frank was to devote most of his life to designing beautiful rug patterns to be hooked by the women of America. His miniscule pen and ink line drawings are immaculate and leaves one amazed at the difficult task he must have faced in creating these artistic prizes in such tiny form.

His son Cameron described Frank as a bit of a "pack-rat", a comment based on Frank's cluttered files of clipped images that he saved from the various magazines and newspapers that crossed his path. We found samples of such clippings in the maze of recovered materials from the factory. Predominant among the files were dogs, particularly images of the black "Scotty" which he occasionally featured. One delightful 2x3 inch pencil sketch we found shows a white dog peering from behind a kennel at a black Scotty, that demands immediate rug hooker's attention. We do not believe it ever appeared in a hooked rug design. There were also rough pencil sketches of commercial signs that the Garrett's had apparently been commissioned to make.

Salvaged from a water damaged sketchbook we recovered images of commercial work, such as a draft design for a rubber boot manufacturer, an image of automobile tires, a tent and sign sketches– glimpses of Frank in working mode. We found pencil sketches of a lion and a still life of a table-lamp. We also discovered a piece of Frank's stationery which carried a banner proclaiming him as a "Professional cartoonist for Advertising and Publishers", although in our research to date we have not been able to specifically establish him in that role.

One fascinating relic from Franks reference "closet" was

a tiny book–"The Story of the Three Bears and Little Gold-ilocks" from which Frank possibly conceived the idea of his popular Three Bears hooked mat design, the second most popular of all Garret rug patterns after the famous "Blue-nose" pattern.

Frank on occasion basked in the public lime light for his rug pattern designs. Notably was the acclaim he received for his design of a special pattern heralding the Royal visit of the King and Queen to Canada in 1939. This was a time when he and brother Cecil were joint managers of the Garrett empire following their father's death. The pattern depicted two Royal Crowns surrounded by a border, composed of the Shamrock, Thistle and Rose for Great Britain and Maple leaves in autumn colors, representing Canada. It was a design widely acquired and hooked in Canada. Wholesalers could acquire a dozen burlap patterns of this rug, hand colored, for only $7.00 a dozen, tax included. Today in 2007 a similar 32x51 inch burlap rug pattern would cost at retail about $60. each plus tax.

Many of Frank's rug designs were marketed in national publications, particularly the widely circulated catalogues of Eatons, Simpsons and Stedmans, as well as publications such as the popular Family Herald.

In Canada, Eaton's (now defunct department store) even issued a separate hooked rug pattern catalogue in color which featured both the designs of Frank and the Bluenose hooker designed by his father John. By the early 30's about the only non-Frank Garrett art work being reproduced in rug patterns were designs sent to the factory by such major marketers as Bucillia and Fleisher in the United States, a company which

continued to commission the Garretts to reproduce designs for their own exclusive marketing.

It was also during Frank's era that the marketing of most patterns was handled by annual catalogues rather than by the more cumbersome and fragile flyers of the start-up days. Franks talented hand can be seen in images other than rug designs that appeared in this promotional material.

Diversity of designs featured variations from rugs and mats to chair seat covers and footstool tops that flourished during Frank's heyday.

Frank Garrett (Junior) can in fact take full credit for the two most successful rug pattern designs created by the Garrett dynasty. He drew both the best selling images of the famous Nova Scotia Bluenose which is still hooked to this day and for the ever popular "Three Bears" which was the second most popular design he created.

The Designing Garretts Take A Break

Mixing thinners and inks to screen perforated rug patterns on burlap was an extremely dirty job for the Garretts as Mrs Cameron Garrett recalls. They needed an occasional day off work. It was not only the rug designs that evolved over the years but the transportation methods also changed considerably from John Garrett's horse and buggy rug pattern sales trip around south western Nova Scotia to the other handsome vehicles (above) which spanned the late 1800's and early 1900's.

This Cat Loves Hooked Rugs!

When it comes to cats they always appreciate a nice hooked rug to lay on. Eddy MacArthur's factory guardian selected an antique hooked rug designed by John Garrett and refused to "get off" when it was being photographed at the old factory in New Glasgow. Bottom is a pen and ink "Scotty" dog design by Frank Garrett (Jr.) another of the various "Scotties he created.

He Sought the Total Package

John Garrett was a man with a mission. He sought to create the total package of rug hooking beginning with pattern making to creating the finished product. From boyhood on he drew designs and devoted long hours to marketing them. He devised and invented rug hooks and makeshift machinery to speed up production , introduced color coding of patterns, opened a factory and distribution center in both Canada and the U.S.A., established a wool processing plant and dye works as well as a printing shop. Ultimately he had a team of some 30 rug hookers at work creating rugs for sale. He stands (above) in his factory doorway proudly displaying one of his prizes.

Basis for two Patents

John Garrett's "Extra Eye"–Circa 1895

Chapter 7

"Rug making was sandwiched in between a winter's knitting and the spring house cleaning...in those days women didn't spend their afternoons at the movies or bridge, rug making was their entertainment...."(Mrs Charles W.F. Humphrey,Avondale, Pictou County)

The ingenuity displayed in both production and marketing as devised by the Garrett clan was refreshing and advanced but as a trade secret it was unknown to most.

While much of the focus was on the promotional efforts used to develop the rug pattern market our research provided an insight into other pre 1900 thrusts devised by Frank Garrett senior and John E, which indicated their creative touch was present in most Garrett image building techniques.

Consider the impact of the rug lady - an attractive young woman, who possibly, (as suggested by Cameron Garrett), was a member of the original Gerhardt clan who had not changed her name, but often visited her New Glasgow relatives. The second photo in this book was enlarged and en-

hanced from a family photo album and shared with us by his cousin Claire (Garrett) Sutherland..

While the Miss Rug Lady's name is unknown, her image has become for Museum researchers a symbol of the Garrett business. Captured in a Kodak moment by what was probably an old Box Brownie she is posed outside the 1892 rug factory, completely garbed from head to foot in Garrett rug pattern designs. She carries in her hands a Garrett rug promotional sign. The snapshot is a priceless memento of a marketing inspiration and is an eye catcher to this day.

A 21st century rug hooking team of Yvonne Hennigar and Suzanne Conrod laboriously replicated it by using the original John Garrett pen and ink art work discovered in the old factory. It has been issued as a First Day cover stamp. The replicated costume has appropriately become an interim logo for the Hooked Rug Museum of North America project.

This image in fact was the first of a series of hooked rug stamp designs of historic portent that are being published annually as a fund raising project sponsored by the Hooked Rug Museum Society.

By scanning old newspapers, the Nova Scotia Archives and other sources such as flyers –other examples of both John and Frank Garrett (senior's) creative promotions are evident.

While not directly significant to rug pattern marketing such inventive and eye catching approaches identifies how a tiny "one horse" rug pattern designer (John) and his father (Frank Senior) were able to mushroom burlap and rags into an international business operation that substantially influenced North America's earliest indigenous art form.

Consider these attention grabbing examples of pre 1900 promos for Frank Garrett's cabinet making and furniture business :

Hi!
Look Out for
That Car there!
IT'S TO BE SHUNTED THIS
WAY.

It contains a part of our spring stock of Chamber Suites, Sideboards, Extension Tables, etc, which along with our stock now on hand, of every description of household furniture, is to be sold at once at lowest possible figures for cash.

Window Shades, Curtain Poles, in fact everything marked down, so as to clean out if possible every article in the place by the first of August. Still another reduction in our $15.00 Chamber Suite, which we now offer for $14; our $16.50 Suite with beveled mirror goes at $15.00. Please call and be convinced that we mean to give you bargains in furniture--for cash--this spring.

FRANK GARRETT,

58 Provost St., New Glasgow,

It was a period when the horse and wagon reigned supreme and with his shop's location near a one-lane bridge leading into town, Frank was observant and obviously upset with those who broke the bridge "speed limits" and rattled the old planks of the bridge as they raced their rigs into town for his "bargains".

We are unsure whether he composed the following poem or not, but it was an attention grabber for one of his advertisements offering "chamber suites", iron bedsteads, picture framing, furniture repairing and enlarging portraits:

The Bridge

Above the bridge there is a sign,
"Walk your horse or pay the fine,"
The horse trots on, no heed is taken;
The bridge it gets a mighty shaking.
The law's a farce like a lot of others,

Invented by our legal brothers;
Some obey, while some do not,
And o'er the bridge the horses trot.
Take two or three, make an example,
Let them see they cannot trample,
A law so good, and right and just,
Beneath their feet, but obey they must."

PLEASANT REFLECTIONS

1894 has passed away; 1895 is fairly upon us. Reader, in taking a retrospect of the

past year are your reflections pleasant or unpleasant - Has your life been the troubled, which cannot rest, or has it been smooth and unruffled as the tiny lakelet nestling in the bottom of the hills? If you have been in need of anything in the way of chamber furniture, and on visiting our establishment purchased a suite from us, we are certain that when you looked into the clear and perfect mirror, your Reflection would be Pleasant indeed !

A Question Mark Hangs Over Early Flyer!

The technique of using a teaser to promote a product line triggered attention and ensured that potential clients did not miss any of Frank's promotions.

Such an approach to customer motivation raises a question about the significant find by Museum researchers of a rug pattern flyer in which each of some 21 rug patterns illustrated bears a Frank Garrett, New Glasgow, N.S. Patent designation and is dated 1894- a year before evidence shows he purchased a collection of rug pattern stencils from Kenneth Ferguson in 1895 (see Chapter One).

In the flyer, Frank senior claims he **"manufactured the Rug or Mat Patterns. "We make,"** he advertises, **"over 25 beautiful designs in our patent process Mat Patterns-Animals, Birds. Scrolls, Leaves, etc".**

Was Frank Garrett's apparent marketing coup done deliberately in competition against -or- in co-operation with,

his own son John, who had been working hard to create a collection of pen and ink art rug pattern designs in order to launch his own rug pattern business?

Alternatively could it have been a gimmick to encourage Kenneth Ferguson to sell out his business? If not a coup to upstage his son John, the flyer could have been a market test contrived by John and Frank to determine whether the Garrett family should invest in the purchase of the pattern stencils owned by Kenneth Ferguson, who appears to have been contemplating retirement . Conjectures unlikely to be answered even a century later.

One fact is clear, the complete images appearing in the Frank Garrett flyer bearing the 1894 patent date are closely related or are identical to the quarter images on the so called Ferguson stencils. It also now becomes clear from the statement **"in our Patent process"** that it was the replication procedure and not the artwork that both and John Frank fully intended to protect from infringement. The general public at that 19th century date was probably unaware that patent and copyright had two different connotations.

Was This John's "Extra Eye?

The secret of that quietly promoted "patent" process still remained uncertain, but persistent research and re-examination of all available data now makes it appear that we have found the answer to the Garrett dynasty trade secret. **We believe that a process never used before in mass production of hooked rug patterns was patented in two different forms by both Frank and son John.**

The very fact that **BOTH** Frank and John Garrett separately sought and obtained Patents was puzzling to say the least. The fact of two Patents existing and approved however proved one thing to researchers. Each Patent had to be for a different purpose or they could not have been issued.

Even if the pair had not been directly in competition the Patents had to distinctly differ.

We tossed around a concept based on knowledge of the two sets of very tiny rug pattern designs we had found. Somehow their creators must have found a method of making them larger in order to reproduce them in standard mat foundation size. Could some form of projector been used to achieve the enlarging task?

Researchers checked far back into the 17th century to discover what was described as **Lanterna Magica (the Magic Lantern)** which had been developed by employing an oil lamp for illumination and a lens that could project an image onto a wall or screen.

In some instances candlepower was also used as the light source for these early projectors and later when electricity was introduced light bulbs took the place of oil and candle power.

A prolonged search by antique dealers led to acquisition of a German made lantern slide projector wrapped in a yellowed New Brunswick newspaper which displayed the date 1905. That particular projector had probably been around for a decade before being wrapped in the paper – which would be about the same time that Kenneth Ferguson and/ or John Garrett would have been experimenting with pattern reproduction methods.

On first examination our find contained a tiny oil burning lamp with the unusual feature of two wicks. This feature was probably intended to increase the intensity of the projected light. A small metal chimney fed the resultant heat and smoke of the burning wick into the air and away from the projected image. One fact quickly became obvious- the device could not project a solid image, only a slide or negative OR, more significant to Frank Garrett (Sr.) a stencil which had a cut-out pattern through which light would project and cast a shadow on a wall.

While of absolutely no use in projecting John Garrett's tiny pen and ink images, the new found device however proved ideal for the projection of the mind-teasing "Mystery Patterns" which displayed an easily traceable image once projected by the device.

Was this the secret process acquired by Frank Garrett in his purchase of Kenneth Ferguson's stock of Mystery Patterns and did it provide the key tool for the mass production of dozens of mat patterns?

Such projected stencil images would have been easily adjustable in size using the magnified image in appropriate size for each desired full sized rug pattern.

The long sought, but ultimately quite simple method of reproducing the tiny intricate cutout stencils now appeared to be confirmed without doubt. The little stencils were probably sandwiched between two small sheets of glass for insertion in the projection slot of the lantern. This was at least a reasonable solution to our puzzle but we still remained challenged by John Garrett's pen and ink artwork. They could not be reproduced using this identical projection technique.

It took further research to discover another early invention called an "Episcope" or a brand name called **Mirrorscope** (basically an overhead opaque projector) which was an evolvement of the "magic lantern" and was also readily available to John Garrett , being extremely popular by the late 1890's.

The Episcope combined a system of reflective mirrors and lenses to project opaque images (such as photos and pen and ink drawings placed under the projection device.

John could easily have acquired one of the inexpensive low cost toy projectors available at that time to project wall images for his young children. He was probably inspired by the ease of projecting book pages, drawings, or photos with the device and conjured up the idea of projecting his pen and ink rug design art work to achieve his objective of burlap pattern making. Simply by moving it backwards and forward he could project the image to the exact size of the ultimately desired rug pattern.

More likely is that John had seen Kenneth Ferguson using his "Lanterna magica" to project the cut out stencils for reproduction of the Mystery Patterns on burlap and between 1892 and 1894 spent several years making the first of his pen and ink rug pattern designs in the miniature format so they could be employed using this technique.

Such could provide the explanation for the long period of inaction between John Garrett's alleged 1892 start-up date and the first public marketing of rug patterns in 1894. Researchers have been unable to find any record of other early rug art pattern makers using the lantern slide or episcope

devices during their continent wide research into old rug hooking design and pattern making.

This "process" was most likely what John had "patented" around the same time that his father was also patenting the use of a through lens projection to replicate the Ferguson stencils.

Here we at last had a logical explanation for

a) the small size of the Mystery stencils,

b) the miniature pen and ink drawings of John Garrett and

c) the possibility that Frank Garrett (Sr.) would have been able to physically produce seven dozen rug patterns in repayment to Kenneth Ferguson for transferring title of his rug stencils under the purchase contract.

d) we also had two specific and different reasons for John and Frank to each apply for a different Patent process for their two different sets of designs.

A plausible solution for the mass production of early rug pattern art in Canada had now been established, and it differed dramatically from the two processes of wood stamp and tin plate stencil making in the United States. The discovery also accounted for how the Garretts were able to steadily produce massive quantities of patterns at very competitive prices in order to supply an international market.

The patenting of the twin processes in fact permitted them to capture an international market. Little wonder that they kept it secret !

Small "P" Political Savvy

There is evidence in a 1900 flyer issued by John Garrett that an advance decision had been made to market extensively by mail, even if it had to be done by selling production at cost. He was obviously very determined to dominant the rug pattern market.

Purpose of the mail-order approach was to ensure maximum market penetration in areas where he had no outlets or agents as well as reducing costs by eliminating the middleman. It was a Garret strategy implemented through advertising, by which the factory walked a narrow line to simultaneously establish policy and create good public relations within their growing distribution network.

They carefully spelled out their intent not to by-pass their biggest marketing outlets , and remained loyal to all of them from the humble country grocer who offered Rug Patterns and Diamond Dyes to the local housewives as well as to the national marketers and catalogue outlets such as the T. Eaton Company, the Robert Simpson Eastern Ltd., Woolworths, Dupuis Freres, Woodwards and others.

They established up front, that they were prepared to sell at cost to solidly establish market awareness. Note how they did not pull their punches:

> *"We want every Dry Goods dealer in the country to see our patterns and sell them. Some dealers persist in buying and selling an inferior article, because by so doing they make a greater profit.*

> *Others think we want to take the business out*

145

of their hands when we offer patterns by mail, but such is not the case. It is simply our method of placing our goods before the people. Ask your dealers for the Garrett patterns each one of which has John E. Garrett, New Glasgow, N.S. printed on it in plain type. If he does not sell them we will send them by mail on receipt of price. We pay the postage. We make no money on mats sent by mail, as our patterns are on heavy material and the postage amounts to about one-half the price of the pattern. For instance a 1 3/4 yard pattern for which we receive 35 cents by mail, weighs from 16 to 17 ounces and as the postage rate is one cent per ounce, it costs us 16 or 17 cents for postage."

The strategy worked, not only did their commercial distribution system remain intact but at one point their direct mailing lists had reached 20,000 names in Canada alone. The Garrett marketing initiative was already venturing into French language advertising– indicative of an aggressive move into the Quebec and New Brunswick areas where Acadian rug hookers often made their hooked rugs with unique sculptured flowers. The marketing text in this flyer also took an educational turn instead of strictly promoting the product as in earlier editions.

Creating an informative or educational content tended to make the Garrett's flyers more readable and useful and thus probably more effective. Obviously John Garrett had inher-

ited his father's sense of marketing by offering something of interest to achieve good public relations.

The Garretts loved subtle approaches. In this flyer for example they chose to defuse an old myth:

NEVER MIND THE THREAD

"It is strange how people will stick to old ideas, and one of these is that in cutting Hessian or burlap from the web for a rug pattern it should always be cut with the thread of the cloth, that is the scissors should run between the same two threads all the way across, no matter how crooked or how much off the square those two threads may run , and if the material is cut from a rolled web instead of a lapped or folded one, the threads run very crooked near the inside or last of the roll..

"Our patterns are all printed from blocks by our patented process, which are true and fair...... now we know how hard it is to combat old ideas, so we have the material for our patterns put up especially for us in folded or lapped webs, not rolled, so that the threads are as nearly straight as it is possible to get them.

Now we know a great many experienced hookers will say this is all bosh, but try it once. This is an age in which many old fashioned ideas have been exploded and we have been in this

rug business a good many years, and give all our time to it, and we have seen the shape of a good many nice rug patterns spoiled by this pulling of threads which left the finished rug all crooked".

In another example John Garrett baited dealers to carry a wider range of rug patterns or risk customers buying them directly from the factory. He asked:

"ARE YOU A HOOKER OF MATS? And cannot get patterns to suit you, try ours. Your dealer has them or should– if he hasn't we can send them by mail."

There is even a pride building promotion aimed at Nova Scotian rug hookers contained in a 1934 edition of a New Glasgow newspaper article about the John Garrett factory story which states that:

"the making of hooked rugs originated, it is believed, in Nova Scotia." The article continued : " The Pictonian takes no little pride in considering the hooked rug as a product , originally of the skill and inventive genius of the women of this province, for it may be said the hooked rug stands with-out a successful rival as a covering for the floor of a mansion or a cottage.

"It is of surpassing excellence whether seen from the viewpoint of exceeding elegance or from that of common utility, this type of rug is equally satisfactory and pleasing. If properly made, and of the best material, with artistic coloring, they

grow increasingly beautiful as time mellows the different shades into exquisite harmony. It is impossible to speak too highly of the "hooked rug" left us by the Nova Scoiia housewife of the long ago."

Beautiful and ardent phraseology, but like others who have voiced strong claims and great pride in the art, the claim of a Nova Scotia origin for rug art is simply not validated. Place of origin of rug hooking has never been substantiated. Historian/architect William Winthrop Kent who conducted extensive and qualified research on the subject in the British Isles and concluded that "emergence of the hooked rug was in old Acadia which encompassed both New England and the eastern Canadian provinces."

Museum researchers are now conducting their own independent studies into the ability of farmers throughout old Acadia to produce materials used in mat making which in itself may provide a clue to the specific area in which the first hooked rug was created. Surprising results are emanating from this research and they will result in another validated research document to be published shortly in the **Rug Art** series by Author House Publishing and the Hooked Rug Museum research team.

The Garretts quickly discovered the most effective returns for their advertising dollars lay in such publications as the popular rural pulp magazine "The Family Herald" which blanketed rural homes across Canada and was read cover to cover. Records show that the Garrett factory had annual advertising contracts in place. Also achieving a wide

national circulation and serving as a mail-order shopping center for rural Canadians were the Timothy Eaton's and Simpson's Catalogues which found a permanent corner in almost every home. The now defunct T. Eaton Company catalogue provided the single largest marketing outlet for sales of rug patterns in Canada.

The Garretts were ever aware of the benefits of alliances, both with supportive industries and with other pattern makers. Copies of old brochures and flyers recovered from Frank Garrett (Junior) files gives some insight into how they marketed their popular new Bluenose rug hook in conjunction with the designs and materials of competing businesses in England and the United States

The factory also printed and donated special flyers to retail outlets on which they could insert their own company name while simultaneously marketing the Garrett merchandise, thus ensuring greater marketing exposure at low cost.

Profitable linkages were established with Bernhard Ulman Co. Inc. marketers of Bucilla Yarns and patterns. in the United States. Garretts sold their Bluenose Hooker through this source and even imported Bucilla artwork to perforate stencils for re-shipment to the company. The same applied to the active Fleisher Yarn company. Garretts produced patterns for them and hitch-hiked Bluenose rug hook promotions and sales through their flyers. Similar tie-ins were employed with the Bates and Innes Ltd. mill in Ontario, Colonial Yarns, Bartlett Mills in Harmony, Maine and many smaller outlets such as The Rug Hatch in Gloucester, Mass. This was the early 1930's period, probably the most active and financially successful years of the Garrett's near century of operations.

Probably one of the most successful of all the alliances or marketing linkages John Garrett achieved (possibly with the help of Arthur Garrett's contacts) was the long standing partnership with the W. CUSHING and Co. Manufacturers of "Perfection Dyes" , Dover-Foxcroft,Maine in the United States. The Garrett factory files contained various flyers issued by Cushings. Each such flyer displayed at least a dozen Garrett rug patterns along with the famous Bluenose Rug Hooker. It was another smart way to gain entry into households where rug hookers were using patterns. The flyers may well have been a loss leader or cost-sharing arrangement between the Garretts and the Cushing Co. The Cushing name survives to this date, the company now under the umbrella of well known rug hooking entrepreneur Joan Moshimer's Rug Hooking Studio of Kennebunkport, Maine.

This alliance between Cushings and Garretts may have been initiated by John Garrett to avoid an otherwise competitive situation where Cushing could have introduced their own rug pattern line. This in fact was what happened in Canada when another very adept marketing company called Wells and Richardson Co. Ltd of Montreal, Quebec introduced DIAMOND DYE MAT AND RUG PATTERNS in an early 1900's flyer which appeared to emulate the 1900 John Garrett newsprint flyer. In the Diamond Dyes flyer the Wells Richardson Company marketed 16 of their own pattern designs- several of which closely paralleled the John Garrett patterns. They also had a United States operation in Connecticut.

A later edition of the Diamond Dye Mat and Rug Pattern flyer offered 33 new designs indicating that they were ag-

gressively competing for market share. A serious competitor to the Garretts, they also imported quality Hessian burlap from Scotland and were to meet the same fate of diminished business when the two world wars depleted the supply of burlap and war work diverted the attention of rug hookers.

They developed a full color catalogue offering 32 dyes for wool and silk and 16 for cotton and mixed goods. Their designs catered to the "habitant" market in Quebec, featuring such items as snowshoes and toboggans. Their familiar metal dye cases and marketing also reached well into the Maritimes. Early examples of their advertising were as ingenious as the Garrett marketing and their 1899 color plate catalogue issue was hard to match for John as he struggled to establish a toe hold in the competitive market.

A rare original hand hooked Mystery pattern rug (above) has been salvaged from an Ontario auction and is destined for the permanent collections of the Hooked Rug Museum of North America courtesy of the Burlington Hooking Craft Guild. Measuring 34x76.5 inches this image from the past matches both the early John Garrett pattern numbers 326 and 202 but the corner scrolls are of a style closely related to the early hand-cut paper stencils employed by auctioneer Kenneth Ferguson to print what are believed to have been the first commercial rug pattern designs in Canada, Frank Garrett (Sr.) John Garrett's father acquired more than 300 of these stencils via a hand-written contract when Ferguson retired. There are examples on record which show that both Frank and John replicated components or all of some of these stencils as their extensive marketing and production opera-tion unfolded. Designer of the Mystery pattern stencils is unknown, but suspected to be of New Brunswick origin and extensive research is continuing with the hope of eventually resolve the conundrum.

HONORING THE GARRETT DYNASTY

The Garrett rug pattern dynasty is the first entry in the Museum's Rug Hooking Hall of Fame. Honored because of their amazing contribution to North American Rug Hooking are John E. Garrett's two families Top-Arthur (1888-1954) Frank (Jr.) (1888-1958) Katherine (1894-1963); Cecil (1902-1954); and John E. (1865-1937)

Bottom photo- John Garrett, second wife Elizabeth (1918-2003); Jack) (1935-2003); and Alberta Henderson (1882-1960)

Chapter 8
Garrett Colorists

Some people like to weave, while others like to knit; It makes them mentally alive, and keeps them feeling fit. Some people like to sew while others like to cook. To make a speech, or do a show, - but I prefer to hook! (Mrs Thomas A. Bowers, 1961 Pearl McGown NEWSLETTER.

As our research transported us along the ever changing Garrett dynasty landscape there was a disturbing lack of information about the contribution of the female staff of the factory that had behind the scenes contributed so much to its ultimate success.

Within the remnants of the old factory building we had pinpointed the location of the high stools and the production line where the hand coloring of the drab burlap designs converted them into enticing colors as a guide to their ultimate conversion as mats by rug hookers.

The coloring of key portions of the burlap rug patterns in the Garrett factory first became evident in John Garrett's

1894 patent images of his rug designs but appears to have come of age in the late 1910's to early 1920's. Color coded patterns were introduced as a guideline or option to help rug hookers who had difficulty in creating their own color plan.

As a marketing feature it was also a necessity in order not to be outdone by other aggressive competitors.

The actual hand coloring of burlap rug patterns was completely accomplished by locally hired women. Payment for their repetitive task was often based on piece work, although a few permanent employees were usually involved in this demanding work as well.

The first stage of the process was necessarily the creation of the pattern. The black ink combined with carefully calculated driers (depending on humidity levels), was brushed through the tiny perforated holes of the paper stencils. After this phase of the printing the burlap would be hung on small wooden wheeled carts to permit them to dry without smudging the image. (Several badly damaged examples of these have been salvaged for the Museum displays. Once dry they were taken in stacks to the coloring gallery which was located on the main floor of the factory.)

The colorists would be seated on high stools facing a wall. Overhead a cable conveyor belt would bring the patterns to the table where each artist would brush in the colors as specified for each pattern.

Each of the artists had bottles of varying toned paints before them and they used long handled round brushes to spread on the specified colors in each pattern. Later, after the colored paint had dried, the colorists would also be involved

in the careful folding of each pattern for shipping to customers.

Despite failed press appeals in the Pictou County region we were able to identify some key individuals through early time sheets . Two veteran colorists were **Miss Fanny Connors and Mrs Bill Urquhart.**

"We each mix our colors from powders, so as to give individuality" said Mrs Urquhart in one New Glasgow Evening News interview during the time Cameron Garrett was the company manager. She joined Garretts in 1941 and was rehired after the War.

Fanny Connors employment dated even farther back, having started with the Garrett factory in 1918 just after the end of the First World War.

Work sheets for the 1952 to 1954 period shed some more light on this generally undocumented work role at the factory. Information about veteran employee Fanny Connors provide us an insight into her accomplishments. Her largest single week of producing hand-colored rugs was Oct 3, 1952. In one six day period she personally hand colored 436 patterns hitting a one day high of 100. In addition to seven hour work-days she also compiled five hours of overtime in creating that record. Her assignments not only included hand-coloring but she assembled and boxed rug hooks for shipment, she also packaged KDC patent medicines and folded mat foundations as well as applying colored yarns to sample cards and stitching the edges of cut burlap. Based on research she also appears to have held the factory record of having colored 128 rug patterns in a single day.

Work-sheet records discovered by the research team iden-

tified other women of the Pictou County area who worked more or less on a part time basis at the plant- some of whom are believed to have also hooked rugs for the Garrett export business, likely on a work at home basis.

These included:

Grace Murray- She regularly hit a daily level of hand coloring 50 patterns.

Dorothy M. Pitts (Trenton)-1952 She held a record high of 61 hand colored patterns. (Her time sheet was the only one found that indicated a unit pay rate of ten cents per pattern completed.

Jean Anderson-Another "regular" she averaged nearly a 50 pattern a day rate of coloring , hitting a high of 324 in one week over a 72 hour period with a single day high of 85.

Kathleen MacDonald -1954. She both colored rug patterns and on occasion assembled yarn materials.

Joan Murphy- Her role was hand coloring patterns and folding the completed burlap mat bases for shipment to consumers. She averaged around 50 a day

Margaret Urquhart- 1954. She colored rug patterns, boxed rug hooks and folded mats- reaching a one day production high of 75 hand colored patterns. Her sister in law named **Peggy** was also employed at times according to retired manager Cameron Garrett.

Note (*While the recovery of these old worksheets opened a little known window into the factory operation it only provided information about the colorists over the brief 1952–54 period and we are aware of other references to as many as 30 colorists at work during busy periods during the 1920's and 30's for which at the present time we have no information*).

Colors With Another Purpose

By the early 1930's John Garrett observed that the success of his invention of the highly popular Bluenose Rug Hooker (introduced in 1926), coupled with a shortage of used clothing suitable for recycling into hooked rug material was creating an increasing demand for yarns. To supply this need the Garrett firm for the first few years imported a line of high grade yarns from England but due to delivery delays the Garretts decided to launch a woolen mill of their own.

Again, use of color was a significant item for consideration and John decided to effectively link his colored mat bottoms to commercially consistent dyed yarns especially made for rug hooking and appropriately sized for the most effective use in operating his mechanical rug hooking machine.

By 1933 he had acquired a building in downtown New Glasgow, near the pattern factory itself and purchased commercial equipment which could produce a high grade 100 percent wool rug yarn in an amazing range of 40 solid colors. Besides the rug yarn the plant also produced knitting yarn- all made from the wool of Nova Scotia sheep. We also have proof of a Steam and Dye works associated with the factory itself. The Garrett's Bluenose "Bouquet" Rug

Yarn, as the wool factory's production was named, sold in Simpson's (Canada) catalogues of the day for 23 cents per two ounce skein and in the United States at 60 cents per a four ounce skein.

In an introductory advertisement for Bluenose Rug Yarns John Garrett proclaimed: "Bluenose Rug Yarn and the Bluenose Rug Hooker are fast growing in favor. Thousands of women have found they can make better rugs in a fraction of the time. In fact, the Bluenose Hooker has transformed rug making into a most enjoyable pastime.

> *"The BLUENOSE RUG YARN is an all wool yarn. Comes in a wide variety of lovely shades. It is useless to attempt to describe a Rug made with this yarn. You really must make one yourself to fully appreciate its charm and to realize the keen enjoyment there is in the making of a rug."*

Demand for the Bluenose "Bouquet" yarn was strong, fed by the popularity of the Bluenose Hooker machine but increasingly John Garrett was having difficulty obtaining sufficient wool to maintain production levels in the wool factory. The commitment to use Nova Scotia yarn had to be extended to fill the orders.

"The local firm reports that raw wool is scarce in Pictou county and a considerable quantity is purchased from Antigonish and Guysborough counties."

The Halifax Chronicle on Jan 16, 1936 reported a substantial order being received " The order is from the Domin-

ion Rug Company of Ontario, which formerly purchased their yarns from factories in England. In October a trial order was placed with the local firm (Garretts) and proving satisfactory, a second order for 2,000 pounds was received. As it was being prepared for shipment a third order for 3,000 pounds was received."

The weekly output of the local plant according to (then) Town Councillor Frank Garrett, one of its officials, is about 1,000 pounds of yarn in about ten colors. According to information the Toronto firm turns out about 600 rugs weekly for which is needed 1,400 pounds of wool yarn.

Hand Carving Discovery

A wooden handled tray with a flat bottom was also salvaged and purchased by researchers inspecting the old factory and such was believed to have been used for transporting the patterns from the stenciling area to the coloring table.

Upon closer examination it was discovered that carving of some sort appeared to be showing in the wooden base. The crude pair of wooden handles were then removed from the base to unveil another striking art discovery.

The two by three foot wooden platform, first thought to be scrap wood, materialized into a very magnificent and irreplaceable hand-carved wood cut. Carved in reverse its inscription could be read in a mirror. It's message:

"STEAM LAUNDRY AND DYE WORKS"

(Researchers also found an old black and white photograph of the Garrett factory which showed "The Printery" on the

street portion of the plant and "Steam Laundry and Dye Works on the opposite end.. It was also known that for a period of time the Garrett's operated a "printery" where it is believed they produced some of their numerous brochures and promotional flyers –but there has been no mention in any early archival materials that they also operate a Dye Works . In retrospect it could have been utilized to dye the wools which were being spun into the Bluenose Yarns the Garretts were also manufacturing at the time. The trail from that grimy and water damaged basement took many tangents.)

The S.S. ACADIA, Eastern Steamships

This rug was hooked by Henry Pace of Trenton, Nova Scotia. It sold in Yarmouth, N.S. many years ago for $20. A unique design it received substantial press coverage for its quality and attention to detail, evidence that innovation existed despite commercialization of designs

Chapter 9

Torpedoed by Nazi U-Boats

THE BEGINNING OF THE END

Sadly, the ravages of war were about to sink the Garrettt rug hooking dynasty beyond the point of recovery.

When the supply of burlap for the manufacture of rug hooking patterns diminished in the early 1940's rug hookers throughout North America shrugged their shoulders and blamed the problem on the war and the lower availability of most consumer goods. A bigger worry for most was food and gasoline rationing and how to keep their Victory Gardens as productive as possible.

Unavailability of burlap however was in the process of striking a fatal blow to the heart of the thriving John E. Garrett rug pattern business . Suddenly the company realized it was impossible to acquire the raw product on which their international marketing was based. The business was indirectly under attack, threatened for imminent destruction by, of all things, Nazi torpedoes.

The Garrett pattern company's woes began in September 1939 when Germany invaded Poland and Great Britain and

France rallied to the defence of a shrinking Europe which was being victimized by Hitler's Panzer divisions . The immediate future of rug hooking itself was bleak. It was an innocent victim of the Nazi submarine fleet's challenge to the long standing supremacy of Britannia "ruling the waves" of the North Atlantic.

Shipping across the North Atlantic from Scotland where Indian jute was being manufactured into high quality burlap to exacting specifications for the Garrett rug pattern factory in New Glasgow, Canada was now imperiled. The factory's source of supply was a victim of torpedo attacks and it was soon to be cut off.

There began at this point to be a long hiatus for North America's oldest folk art form as the six year Battle of the Atlantic unfolded with a horrible toll of both surface and underwater ships and on the thousands of crew members who sailed in them.

The infamous German U-Boat "wolf-packs" were destined to cripple and eventually close down the Garrett pattern making business along with many other things. The losses of ships and men that the raiding submarines inflicted on the Allied nations was shocking, and the disastrous impact on imports from the British Isles to Canada was devastating to both economies. The surviving Garretts were forced to temporarily close the pattern factory itself. They sought employment in wartime industries of the area.

The 1941 Bluenose Hooked Rugs catalogue was 16 pages long, published in both Canada and the United States but it failed to make even the faintest mention of what was transpiring behind the scenes.

Loss of the key source of burlap was not being publicly anticipated but behind the scenes it was of growing concern to the company. Other uncontrollable factors were also unfolding. The reserve supplies of burlap throughout North America was rapidly diminishing.

It was during this same period in Canada that efforts were being made to recruit the first women into a Canadian Women's Army Corps and eventually into counterparts serving both the naval and air force branches of the Canadian Armed forces. The women of Canada were needed, as Winston Churchill pointed out to Canada's government of the day, to free more men for active duty on the front lines. Some 22,000 of them were to join the fledging Canadian Women's Army Corps, the first women's military organization in Canada. Rug hookers were moving into many tasks normally done by their male counterparts as the men-folk were recruited for war.

The war-effort and the hiring of women for jobs previously occupied by males also extended to the manufacturing industries, some of which were being converted to ship building, and arms and munitions manufacturing. It was a time of social change during which a new era was to dawn for women in the work force.

They were being enlisted to help fight the common enemy, and eagerly rose to the challenge. They would never look back. A parallel situation was to follow shortly thereafter south of the border as the United States also joined the fray against Adolph Hitler's rampaging Nazi regime.

Since women were by far the majority participants in rug hooking the diversion of many thousands of them to all as-

pects of the War effort not only removed many of them from rug hooking entirely, but also taxed both the time and physical strength of those who remained as home-makers. Filling the manpower gap reduced or eliminated their participation in rug making. Subsequently, even without the difficulty in obtaining burlap, Garrett's rug pattern sales were doomed to drop dramatically.

From Bad to Worse !

The Battle of the Atlantic was to open ominously in the Fall of 1939 with U-Boat 39's attack on the Royal Navy's aircraft carrier ARK ROYAL. Only 3 days later the fleet carrier COURAGEOUS was sunk by Nazi U Boat 29.

Counter attacking, the British mined the English channel and by October had claimed three German U boats in a single 24 hour period. Another pair were sunk off the coast of Ireland when they attacked the first convoy of the war. By December the first Troop convoy set sail out of Halifax for England –the war at sea was effectively in full sway and was not destined to end for six long and tragic years of losses on both sides .

For the Garrett factory the prospects for the immediate future were frightening. They had pinned their plans and ultimately their economic fate on a major Hessian burlap manufacturing plant on the west coast of Scotland which manufactured an extremely high standard (and expensive) type of burlap in both quality and special weaves.. This particular high quality burlap had been designed to work most

effectively with the Garrett's Bluenose Rug Hooking machines that had proven so popular.

The Battle of the Atlantic was to wage incessantly over a six year period as England's North American allies first Canada and then the United States persisted in the face of horrendous losses in men, ships and materials to keep the British Isles supplied by merchant transports which in the face of great odds continued to ply the North Atlantic with the essentials for survival and military equipment needed to counter-attack and overcome a powerful enemy.

Generally the shipment of wartime supplies was west to east, but when opportunities beckoned a few manufactured products from Britain were sent as cargo on the almost empty merchantmen making their way back across the North Atlantic. It was on such ships that the Garrett's decided to risk the acquisition of at least two and possibly three shipments of Hessian burlap from Scotland.

That decision was made by Frank Garrett (Jr.) the company's reigning artist and by Cecil Garrett who managed the company's business operations. Failing success they would be forced to close down the plant for lack of material. Their father John E. had passed away on May 16, 1932 and sons Frank and Cecil were joint managers of the New Glasgow operation at the time, while Arthur continued to head the United States plants in Malden, Mass.

Two factors made the decision both intimidating and full of risk. The Garretts had to borrow funds to purchase a bulk quantity of burlap and to make matters worse, no one would insurance such a cargo's risky path through the U-Boat wolf-packs that viciously sought to attack anything that floated.

It was a fateful "do or die" decision that the two brothers were forced to make. By early 1941 Germany's surface warships had claimed 37 ships of 188,000 tons and U–Boats had torpedoed 38 more totalling almost 200,000 tons and the War had only just begun.

In April alone a Halifax convoy was attacked in a two day running North Atlantic battle that claimed ten merchantmen. A few days later a return convoy lost 4 more ships.

Around this time the war at sea was to take a new turn- a British boarding party was successful in not only capturing Nazi U Boat 110 but in boarding her and capturing invaluable coding equipment which was to permit England's intelligence agencies to eavesdrop on enemy attack ships and decode their movements until war's end. Ultimately it provided the edge for the Allies to win the Battle of the Atlantic, but sadly it was too late to save the Garrett rug factory production line.

The German's changed their tactics from solitary U–Boat attacks to wolf-packs of submarines which stalked convoys simultaneously and in large numbers. Ten U–boats for example hit Halifax convoy 133 and sank 5 ships while losing two of their own. One of the first U.S.A. convoys of 38 ships and 11 escort vessels was attacked and 9 merchantmen were sunk while 4 destroyers were lost.

The war came ever closer to home. An August convoy SC944 with 33 ships was attacked repeatedly over 5 days by 17 U-boats and 11 merchantmen were sunk. The raiders even entered the St Lawrence river where U91 sank seven ships before being sunk herself. That same October saw convoy SC104 losing 8 merchantmen out of 47 ships when under at-

tack by 15 U boats. The odds against survival of the Garrett rug factory were becoming overwhelming.

At least two shipments of the Garrett's burlap orders were torpedoed and along with it went hopes that the firm could maintain even a semblance of operation though the wartime period.

Attempts at temporary diversification had failed. The factory was closed until the war end and both Frank and Cecil accepted employment in war-related New Glasgow area industries. Their highly skilled team of employees was also dispersed. It was a shallow victory for Frank and Cecil to see the ultimate defeat of their undersea nemesis in 1944 as Germany experienced U-Boat losses averaging about 13 a month in the waters off Africa. Sadly the Garretts had to carry the financial burden of repaying bank loans taken out to pay for burlap that to this day still carpets Davy Jone's locker.

As the 50's dawned they had the courage to attempt the rebuilding of the Garrett pattern business but a new enemy –the grim reaper, was already lifting its ugly head. Cecil passed away Feb 16, 1954 at the age of only 56. Arthur,(manager of the Malden plant) died in June of 1954 at the age of 66 and Frank (Junior) was to die in May of 1958 . It was a triple blow to a company struggling for survival.

Frank "Cameron" Garrett (son of Frank, Junior) who was born in June of 1929 was left to pick up the pieces.

He made a valiant effort, diversifying the company into everything from skate sharpening to the sale of antiques and had some measure of success. The rug pattern business however continued to diminish. The demand for patterns never

recovered their pre second world war peak. The last rug pattern catalogue was printed and circulated in 1974.

Cameron's talents were oriented more like his great grandfather namesake (Frank, Senior) whose reputation was built around fine woodworking and furniture design . The son of Frank William and Elizabeth (Cameron) Garrett had worked in the factory as a teenager–one of his tasks being to operate the upright lathe ,cutting and polishing the metal hooks which were inserted into wooden handles, mostly imported from Ontario.

After graduation he took a two year teaching course at the Provincial Normal school in Truro and taught at Greenwood school and at East Pictou Rural high school but his career was cut short when his father Frank became ill and he was needed to manage the factory operation.

In 1953 Cameron married Virginia Grant Buck, also a former teacher. They had three children.

He also taught wood working at a local school's industrial arts class where one of his students was Edward MacArthur. He used his talent to modify some of the pattern making equipment in the factory to make it more efficient. One example was a pair of wooden cones he fashioned to provide a belt controlled rheostat to regulate the speed of a paper pattern perforation device.

Cameron told us– "We struggled to create a few new rug patterns including the Confederation rug, but that was the last one to be produced in the factory. Miller Tibbetts helped us from time to time with the art work and catalogues."

Enlarging on that information was a newspaper article in the New Glasgow Evening News (October 23,1967) a Gar-

rett employee, Mrs Bill Urquhart was quoted as saying that the same Miller Tibbets "had also provided new designs" and that Jack Cunningham a New Glasgow area auctioneer had also assisted the company at both printing patterns and making steel hooks.

The Garrett factory was experiencing a minor upswing in business around this date, although mats were no longer being hooked at the plant -"**as they were in the heyday when some 18 girls were employed, hooking.**"

Hooks were still being manufactured for sale but the popular Bluenose Hooker had been discontinued as parts had been manufactured at the United States plant which was now closed. The yarn plant had also been closed and wool was now being imported from Paris,Ontario.

One of the newer ventures was a marketing and promotional effort to introduce small needle point canvases which were stamped in color and sold individually or in kits which included six strand embroidery cotton in the required colors. The featured design of a cottage with a sail boat tied up at a wharf looks much like a pencil drawing recovered from an old Frank Garrett sketch book.

During our first visit to the former Garrett factory we were fortunate to purchase an original Cameron Garrett rug design hooked rug. It was his Confederation (1867-1967) pattern and hooked by a Mrs Langille of nearby River John where her brothers operated a feed business. Centered by a stylized maple leaf containing 11 equally sized triangles in multiple colors surrounded by a fringe of flowers, they represented nine provinces and two territories .

Cameron proved to be adept as his great grandfather in unique marketing methods. The New Glasgow Evening News recounted in a Dec 29, 1965 story his comments about an old-fashioned bedroom antique" :

" Which used to be stored under the bed being useful today as punch bowls," had brought in tourists from the United States asking for the same. They got the story from friends, I guess, but they came in the store and asked if this was Garretts where the old punch bowls were available- and they cleaned our stock out....and yep, they knew the original use."

Virginia (Buck) Garrett , Cameron's wife, recalls him coming home after work blackened by printer's ink from printing burlap patterns. She remembers when as many as twenty women would be hand-coloring the burlap mat bottoms. She cherishes three old Garrett factory patterns in her personal collection- the Three Bears, (hooked by herself) a Maple sugar camp (hooked by her ancestor Julia Cameron (her grandmother) when she was 86/87 and a floral/scroll image by her mother the late Margaret Buck,

Cameron eventually hired Edward MacArthur to manage what was left of the of the rug factory and eventually sold him the building and remaining components of the old factory which had survived the tempestuous war years . Eddy still operated the antique shop in 2010.

YOUR HELP IS NEEDED

The Hooked Rug Museum of North America has acquired an 8,750 sq.ft. concrete block structure at 9849, St. Margaret's Bay Road, R.R.# 2, HUBBARDS/ Queensland, N.S. B0J 1T0 It will be opened when sufficient funds have been accumulated to undertake renovations to international Museum standards.

The complete project will include a Market place for rug hooking in order to assist the project to become sustainable. It will contain a demonstration area, classrooms, an archival research center, contemporary galleries and major exhibition facilities. It will become the first museum in the world that is dedicated to rug hooking. Estimated cost $500,000.

CAN WE COUNT YOU IN? Your Museum needs financial assistance to complete interior renovations on the Museum. Total estimated cost to door opening status is $500,000.

Financial Contributions may be sent to: The Hooked Rug Museum of North America Society

P.O.Box 556,Chester, N.S. B0J 1J0 Enquiries to Suzanne Conrod, Founding Director

902-275-5222 E-mail dornoc@eastlink.ca

Web site at www.hookedrugmuseum.org

Honorary Chair person- Hon Myra Freeman

Founding Director- Suzanne Conrod

President – Tom Murdoch

Vice Chair- W.Hugh Conrod

Governance-David Bond

Chief Financial Officer-Ian Grant

Treasurer- Sherry Chandler

Building—Phillip Ellwood

Directors at Large - Anne Smith, Phyllis Lindblade, Vicky Calu, Nancy Blood, Mamie Adair, Celeste Bessette, Mary Lou Justason, Nancy Blood, Sally Ballinger, Ruth Thompon, Erin McKenna

NOTE-- *Future editions in our Rug Art series of authentic hooked rug research discovery stories will soon be published. If you wish to be advised of such please send us your e-mail address for updates.*

The Hooked Rug Museum of North America Society is designated as a Charitable organization under Canada Revenue agency Income Tax Regulations www.cra-arc.gc.ca/charities. Our Tax Number is 85513 7964 RR0001

RESCUE OUR ENDANGERED HERITAGE

We need hooked rugs and financial assistance to complete the challenge of opening rug hooking heritage to the public-can we count you in?

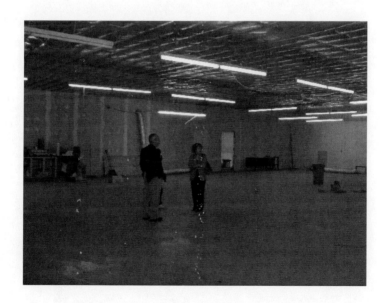

The Hooked Rug Museum of North America

P.O. Box 556, Chester, N.S. B0J 1J0

Lest We Forget

Endangered Rug Heritage

A Hand Carved Treasure from the Past

Another amazing prize from the 19th century rug art dis-covered by HRMNA researchers is this unrecognized and ignored hand-carved rug pattern design. This rarity and two others cry out for those who can help save such relics and honor their creators . North America's rug hooking heritage is an endangered art,

Lest we forget, the discoveries in this research only scratch the surface of a heritage that has been ignored for far too long.

Samples of John E. Garrett Rug Art
ORIGINAL PEN AND INK DESIGNS
FOUND IN NOVA SCOTIA

(John's earliest designs were not issued in a series. The first Garrett series identified to date are the Scotian Patterns, second were the Bluenose designs) .None of these two series are now copyrighted since 2008.)

Pen and Ink designs
Frank Garrett (Jr.) and father John E. Garrett
A STUDY IN CONTRAST

The pen and ink artistry of Frank (Jr.) and father John E. Garrett are contrasted in these similar designs of a horse portrait. The period of creation is more than a quarter century apart. Oldest work (bottom) is by John, the factory founder.

The Tree of Life-From the Original Art

One of the more popular designs by John E. Garrett was his rendition of the Tree of Life, (above) which was usually adapted by rug hookers to relate details of individual family histories.

1351

Pen and Ink Rug Art by the Master

Frank Garrett (Jr.) studied art in New York in the same classes as the great American folk artist Norman Rockwell. Two of his beautiful creations are illustrated here. His original pen and ink art was "rescued from oblivion" for future generations to enjoy.

Rug Art –Grown from Seed
GETTING TO THE ROOTS OF HERITAGE

Unveiling a validated theory about the origins of North American Rug Hooking . Learn why pioneer rug making is our continent's most endangered art form. This new heritage research book is the second in the Rug Art series of books created for the Hooked Rug Museum archives. COMING SOON!

Garrett Family Genealogy

	Name Date of:	Birth	Spouse	Death	Parent
1)	John Gerhardt	n/a		n/a	n/a
	Annie Barbara McGeorge	n/a	wife	Jan 5, 1891	n/a
2)	Frank Garrett (senior)	Aug 21,1839		July 3, 1912	#1
	Agnes (Bonnyman) Garrett	Nov 3,1983	wife	May 14, 1895	n/a
3)	John Edward Garrett	March 31, 1865		May 16,1937	#2
	Laura (Bonnyman) Garrett	1866		Oct. 5, 1907	n/a
4a)	Arthur Garrett	1888		June 1954	#3
	Katherine Wormon	n/a	wife		n/a
4b)	Frank Garrett (junior)	Sept. 1889		May 1958	#3
	Elizabeth (Cameron) Garrett	n/a		n/a	n/a
4c)	Agnes Katherine (Garrett) Gregg	Nov. 20, 1894		March 20, 1963	#3
	Donald Lamont Gregg	June 10,1884	husband	May 31, 1961	n/a
4d)	Cecil Edward Garrett	May 25, 1902		Feb 16, 1954	#3
	Annabel Fraser (Robertson)	Nov 18,1901	wife	Sept 12,1977	n/a
5a)	Frank Cameron Garrett	June 29,1929		n/a	#4b
	Virginia (Buck) Garrett	n/a	wife	n/a	n/a

	Name Date of:	Birth	Spouse	Death	Parent
5b)	Claire Fraser (Garrett) Sutherland	April 11,1931		n/a	#4d)
	Hugh Vernon Sutherland	n/a	husband	n/a	n/a
5c)	Laura Anne (Garret)	Sept. 17, 1929		June 24, 2000	4d)
	James Arthur McNamara		husband	Feb 15,1991	n/a)
5d)	Arthur Edward Garrett	May 17,1932		n/a	4d
	Margaret Sylvia (Flood)Garrett	May 7, 1960	(wife)	n/a	n/a
6a)	Susan Garrett	n/a		n/a	5
6b)	Frank Kim Garrett	1955		n/a	5a
6c)	Rev. David Garrett	April 1, 1959		n/a	5a)
6d)	Janet Anne Sutherland	April 1, 1959		n/a	5b
	Patrick James McGill	Nov. 21, 1987	(husband)	n/a	
6e)	Ruth Katharine McGill	July 28,1960		n/a	5b
6f)	Anne Elaine McGill	Feb. 9,1963		n/a	5b)
	Andrew Taylor MacAulay	Sept. 10, 1988	(husband)	n/a	n/a
6g)	Cathy Jayne (Garrett) Alchorn	July 3, 1961		n/a	5d
	Kevin Linus Alcorn	n/a		n/a	n/
6f)	Donald Arthur	Dec 13, 1962		n/a	5d)
7a)	Brian Stephen Garrett	May 15,1986		n/a	6

Name	Date of: Birth	Spouse	Death	Parent
7b) James (Gary) Garrett	Dec 31,1954		n/a	5c)
Susan Mary Colantti	Sept 17, 1983	wife	n/a	n/a
7c) Nancy Claire McNamara	July 9, 1957		n/a	5c)
John Alexander MacKenzie	Sept 23, 1955	husband	n/a	n/a
7d) Ross Arthur McNamara	Nov 8, 1963		n/a	5c)
Lisa Jo-Anne Ralston	June 6, 1992	(wife)	n/a	n/a
7e) Janet Anne	April 1, 1959		n/a	6d
7f) Erin Ruth-Anne	May 2, 1993		n/a	6b)
7g) Michael Graeme	March 20, 1997		n/a	6c)
a) Katherine (Katie Anne)	March 15, 1990		n/a	7)
8b) James Gregory	Ju;y 12, 1993		n/a	#7b)
8c) Matthew Fraser MacKenzie	Dec 19, 1988		n/a	#7c)
8d) Sara Evelyn MacKenzie	Nov. 25, 1991		n/a	#7c)
8e) Laura Anne McNamara	May 9, 2002		n/a	#7d)
8f) Heather Lynn	Sept 30,2004		n/a	#7d)
9a) Garrett Hugh Taylor	Dec. 30,1994		n/a	#6f)

Kenneth Ferguson Background Research

The name of Kenneth Ferguson first came to light in our research documentation while studying a contract between him and Frank Garrett (Senior) and in reference materials in the Public Archives of Nova Scotia. This timeline is included along with the Garrett Genealogy since it may benefit future researchers to better confirm the original creator of the Mystery stencils.

A key reference was that In 1879 in Halifax, there was a store on Brunswick street at the foot of Cogswell street where there were burlap rug patterns displayed. and that the owner of the store made an assignment . The stock was bought by an auctioneer firm, SHAND FERGUSON AND CLAY."

Cecil Garrett, factory book-keeper was quoted "When this firm started to retail the stock, they were afraid the rug patterns would not sell, and they marked them down with the result that they were the first thing that did sell. Mr Ferguson, who was more or less an artist made some more patterns and they sold. Later on this man Ferguson moved to New Glasgow and opened a store next door to my grandfather's furniture store. (Frank Garrett Senior). He still continued to make mat or rug patterns for the retail trade, and any surplus he shipped to Halifax."

Through Museum Consultant Robert Frame a contact was made with Gary Shutlak who is the Senior Reference Archivist at the Province of Nova Scotia's Archives and Records Management center.

The earliest record identified at the Archives was that one Kenneth Ferguson, auctioneer and feed store opera-

tor was in business at 108 Upper Water Street in Halifax in 1869/70 some 22 years before John E. Garrett launched his rug pattern business at New Glasgow in 1892.. Kenneth Ferguson was next listed as a commission merchant and auctioneer 1872/1873/1874/1875 and later as a bookkeeper 1875/1876/1877. He is not listed in the 1881/1882 directory. In an advertisement in 1872/73 he thanks the public for their patronage for the last six years which based on this data he was in business from 1866. The Halifax Directory lists the firm of Shand, Ferguson and Clay as hardware and ship's chandlers at 205-207 Lower Water Street .

TIMELINE

1866- Ferguson opens business in Halifax (Not known if he was designing or selling rug patterns at this time.

1869/1870- Kenneth Ferguson, auctioneer and feed store operator at 108 Upper Water Street, Halifax, N.S.

1872/73 –Kenneth Ferguson runs an advertisement thanking the public for their patronage the last six years (which would take his business back to 1866.)

1872.73/74/75 –Kenneth Ferguson listed in records as commission merchant and auctioneer (Public Archives of Nova Scotia)

1875.76/77 – Kenneth Ferguson listed as a book keeper
 We also find the firm of Shand,Ferguson and Clay listed as a hardware and ship's chandlers firm at 205/207 Lower Water Street, Halifax, N.S.

Cecil Garrett , speaking at a Halifax service club indicates: "In Halifax there was a store on Brunswick Street at the foot of Cogswell there were burlap rug patterns on display..the owner of the store made an assignment. The stock was bought by an auctioneer firm, Shand, Ferguson and Clay, When this firm started to retail the stock they were afraid the rug

patters would not sell and they marked them down, with the result they were the first thing that did sell.

Mr Ferguson "who was more or less an artist made some more patterns and they did sell."

1879/80 Mr Ferguson's home was in Dartmouth at this time. At an known date in the late 1800's Ferguson relocated to New Glasgow where he operated a rug pattern manufacturing and sales business immediately alongside of Frank Garrett (Senior's furniture establishment

There is a contract signed between Frank Garrett (Senior) and Kenneth Ferguson in which Ferguson sells his stencils and other pattern making equipment to John E. Garrett's father.

The image below is a sample of two of the designs that Frank Garrett (Sr.) patented in his name in 1894.

Water soaked, mouldy
and a few destroyed boxes

The Hidden Artistry of a Great
Rug Pattern Designer

This magnificent portrait of an unknown United States model was painted by rug pattern artist Frank Garrett (Jr) while he was taking art classes with Norman Rockwell early in both of their careers. It hangs today along with other original art in the home of his son and daugher in law Virginia and Cameron Garrett in New Glasgow. Few are aware of this talented Nova Scotian's skills whose rug pattern designs were destined to be tramped on.

Index

(Note) The Garrett family Genealogy is provided for our reader's guidance on pages 185/186/187 and a Timeline for Kenneth Ferguson is located at 190/191.